# The Portrait Painters' Handbook

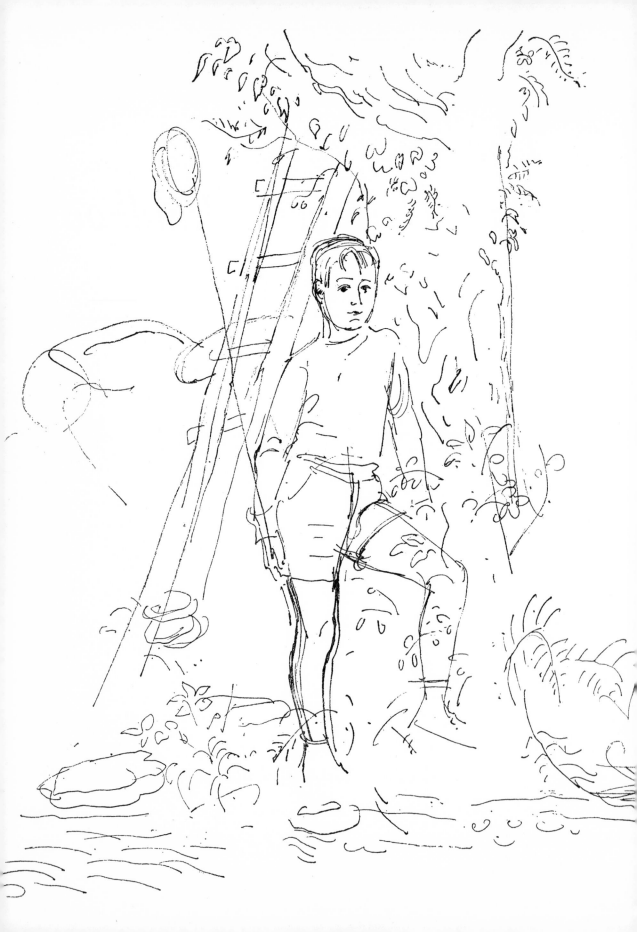

# The
# Portrait Painters' Handbook

## Claude Harrison

*Studio Vista London*
*Watson-Guptill Publications New York*

# Acknowledgements

The author and publishers are grateful to the following
for kind permission to reproduce paintings: to
Mr Peter Sharp for plate 3; to Mr and Mrs Puxley
for plate 5; to Sir Francis Dashwood for plate 10; to
Mrs J. B. White for plate 12; to Dr and Mrs
Middlemiss for plate 13; to Mrs Alastair Morton for
plate 33; to Mr and Mrs John Fenwick for plate 36; to
the Legatt Trustees, National Gallery of Scotland for
plate 23; to the Durham County Education
Committee for plate 26; to the Greater London
Council as Trustees of the Iveagh Bequest, Kenwood
for plates 21, 25. Plates 19, 20, 22 are reproduced by
Gracious Permission of Her Majesty the Queen.
Plates 15, 16, 17, 29 from the Victoria and Albert
Museum are Crown Copyright.

© Claude Harrison 1968
Published in London by Studio Vista Limited
Blue Star House, Highgate Hill, London N19
and in New York by Watson-Guptill Publications
165 West 46th Street, New York, New York 10036
Distributed in Canada by General Publishing Co. Ltd
30 Lesmill Road, Don Mills, Toronto, Canada
Library of Congress Catalog Card Number 68–13480
Set in 12 on 13pt Bembo
Printed in Great Britain by W. S. Cowell Ltd,
at the Butter Market, Ipswich

SBN 289 36876 6

# Contents

Acknowledgements 4

Introduction 7

1 Composition 11
2 Drawing and the problem of likeness 14
3 Painting the head 33
4 The half-length and full-length figure 41
5 The conversation piece 46
6 Portraits of children 58
7 The portrait miniature 62
8 The portrait painter's materials 66
9 Professional problems 82
10 The relationship of painter and patron 89

Bibliography 93

Index 95

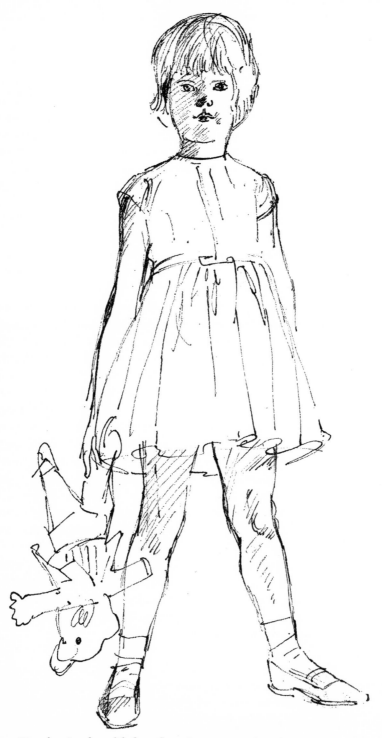

*Atalanta.* First drawing from life for a figure in a conversation piece

# Introduction

My first task is to justify my role, reveal my attitude to the subject and describe the purpose and nature of this book. As a child, the subject of my drawing was always imagined people; and the portrayal of human beings, real or imaginary, has continued to engage my whole attention in what I admire, study, read, or do for myself. I was a student for about six years and, although taught by several painters, who earned at least a part of their living by portraiture, I received from them neither advice nor comment on that subject. Nor, as far as I know, did anyone else. In spite of the noble history of portraiture, in spite of Rembrandt, Goya, Van Dyke and Velasquez, the art has in this century fallen into some disfavour amongst painters so that it is adopted as a profession less often than teaching. I suspect the reason for this to be social rather than aesthetic and likely to be regretted by our progeny.

My first serious commission, to paint the portrait of an industrialist, came whilst I was in my last year at the Royal College of Art in London and the painting pleased neither the client nor myself. I was overawed by the authority and wealth of the sitter and I failed to organize the sittings so that I could execute the work with confidence. Not realising the extent of my ignorance of technical or administrative matters, I assumed I was unlikely to make a successful portrait painter and I continued to paint only my family and friends, or imaginary figures in landscape. I came to be known as a painter of conversation pieces, done as yet only for my own pleasure. An architect saw these pictures and asked me to attempt such a painting of his family and I then began to learn, by trial and error, how to go about the problems of commissioned portraits. As a result of this indirect approach, and because my sitters were usually children and the atmosphere comfortably domestic, I began to gain confidence in working in other people's homes. Even some minor success during one's first years is of incalculable value, for it gives one the confidence to go on.

I have since tackled whatever I fancied and whatever came to hand: murals, abstractions, illustrations and so on. I think of myself primarily as a painter, but I must acknowledge that I am now more likely to be described as a portrait painter and particularly as a painter of conversation pieces, which are simply portraits of more than one person in the same picture.

## TRAINING

It is a noticeable and regrettable characteristic of the British public that they resent and suspect any artist, painter or writer, who makes any change from his familiar subject matter or style. The feeling is so strong that a great many artists accept imaginary fetters on their talents, and I am convinced that there exists a number

of painters who would have made great portrait painters had they not been inhibited from accepting the challenge of working for people who might not share or appreciate any of their own values. It is not essential for the portrait painter to adopt the values of his sitters.

Portraiture appears to be dominated by two primary, equal and occasionally conflicting essentials: making a good painting and securing a good likeness, and the whole loses by however much one is sacrificed to the other. I have always regarded it as an integral part of the whole business of painting, not some trick like producing lightning sketches, cartoons, or silhouettes at the village fête. I therefore consider the most essential training is in drawing, and that you should learn to draw anything with anything: a tree, a bird, a house, an engine or a face with a pencil, a poker, a needle or a brush – and not hope to acquire a superficial sleight of hand that is no better than the parlour trick of drawing a cat by making a figure eight and adding tail and whiskers.

Until about a century ago, the student learned his craft in the workshop of an established master, whilst to-day the overwhelming power of a complex urban society commits him to a college of art.

Although the problems and disciplines remain much the same, the latter course is more in keeping with the times. The older system might have made the more complacent student no more than a pale shadow of his master, but the school can leave him so confused by a multiplicity of models that he does no more than imitate in turn each latest craze. Until recently, the schools were absurdly divorced from the realities of earning a living and it was assumed that when you left you would have no alternative to teaching. I believe this to be no longer the case with the arts that bear a direct relationship to the material life of the country; but for painters and sculptors the problem remains and little practical help is given to them.

Portraiture has long been one of the few reasonably independent fields where they can earn a living whilst practising their art and I would consider that such problems of integrity as are involved relate to the artist's character rather than to his manner of work.

THE AMATEUR

The amateur painter, ambitious to paint portraits, would be well advised to practise drawing from life in a wider context than the local art class. He should draw his family, his friends and himself; he should draw and paint still life at home, and work objectively from nature, dead or alive, until he can represent adequately on his canvas whatever shape he finds of interest. His can be a privileged role, for if he paints only for pleasure, then, presumably, he need please only himself. Few painters can honestly claim such freedom. Yet I have sometimes heard painters, with ample private means, attempt to justify likenesses that pander to some mythical public taste, with the excuse that they need the extra money. I find this attitude as greedy as it is misguided.

I hope to provide some practical information that might help the art student who envisages portrait painting as a career; and I hope to answer some of the

questions that puzzle the amateur who lacks the opportunity to meet painters or who is inhibited from asking direct questions. I therefore devote considerable space to such mundane problems as organization, materials and the relationship between client and painter.

I do not feel concerned with the reader's style of painting, his allegiances or his prejudices, but only with such material problems as I have myself encountered or believe to be relevant.

# 1 Composition

The composition of a portrait is a difficult and subtle problem in spite of its misleading simplicity: just a particular human being and a rectangle, that you must put together to your satisfaction. If you cannot distinguish good composition from the commonplace, then you are likely to be too easily pleased with your designing. Such an ability might be described as an awareness of quality just as the quality of certain lines of poetry or bars of music make you aware that what you hear transcends ordinary experience. Men have always sought to analyse the problem and establish rules that will guarantee good design and occasionally they seem to succeed, particularly with architecture. If you cannot grasp at once, from a fast-moving vehicle, the difference of quality between, say, a villa by Palladio, and one of its more pretentious derivatives, usually a Bank, then you are still insensitive to the values of composition. The sensitivity can be acquired, as the wine connoisseur develops his palate, by familiarity with what has come to be held the best by generations of intelligent and sensitive men. Observe the difference between a coin of Alexander the Great and one of George V, of quality of metal, modelling and design.

However well you apply the famous 'golden rule' of proportion, however many little tips and rules you know and observe, you must, from beginning to end, rely upon your capacity to recognize differences of quality. Without it you will at best design only in characterless good taste. If you want to examine your powers of discrimination, I suggest you go to the great national collections and compare paintings by Piero della Francesca, Raphael, Titian, Poussin, Vermeer and Seurat to the work of their contemporaries. It should be apparent to you that their work has an underlying quality of design, or hidden geometry, composition, plan or plot that is almost invariably stronger and better than that of others.

To find a new pose, or a fresh design that will please you is difficult enough; to find one that will please the subject as well is virtually impossible. Too many portrait painters sit their models in comfortable chairs, in a familiar light and look through their cardboard peepholes to see what best to include, and then just paint what lies before them. A gradual approach is more rewarding: a real composition can grow out of the particular experience, rather than be chosen from what immediately presents itself. This implies making preliminary drawings and small sketch designs, or drawing it full size in charcoal on several canvases or panels.

Something can be learned, good and bad, from the rationalized commercial approach of so many 'professional' eighteenth century painters. Their common habit was to glean a set of dignified postures from the great talents of Italy, ask their customers to choose, paint in the head and then have the rest knocked up by assistants, or even by a specialist in London. This resulted in bad portraits that were

well composed. They look very grand in the great house, but do not bear examination, for too much attention had been paid to the customer's wishes and not enough to his appearance. It is the familiar debasing of an ideal and I believe that the advice Reynolds gave in his *Discourses* still holds good for styles of painting quite unrelated to the 'Grand Manner'. He advised students to study the Cartoons for tapestries by Raphael, then at Hampton Court and now at the Victoria and Albert Museum. Most painters would profit by studying the weathered bones of these noble compositions. They are painted in sized watercolour, now faded, on innumerable scraps of paper glued edge to edge and they are worn out with travelling and the wear and tear of weavers. Designed in the 'Grand Manner' for the Sistine Chapel, now housed, battered and repaired, under glass in a nondescript hall, they are unlikely to make an easy appeal, for no surface charms remain. It is the composition that remains, as firm as ever. If you will sit patiently and explore the Cartoons, their design will begin to take hold of you and lead your attention, as Raphael intended, so that each shape, each posture, each small detail, mass and movement contribute to the complex design and you will come to realize that there is a quality mysteriously pleasing, inevitable and finally resolved.

It might be argued that the composing of a single portrait is small beer compared to such major works and that, by now, every permutation of pose and proportion must surely have been exploited to excess, yet the comparison is only one of degree and the variations are infinite so long as there are people. There has for long been an understandable, if misguided, prejudice against copying the Old Masters and slavish reproduction is as unrewarding as it is laborious, but to make drawings or studies in whatever manner or medium you like is the quickest way of learning. When you try to sum up the painting and record it for yourself you find elements that you had never noticed and whole regions of unexplored design. Rubens, Rembrandt, Delacroix and the majority of major painters copied all their life. They took what they needed out of the works they admired.

Portraits of the artist's family and friends so often represent his best work that it is reasonable to assume the greater the familiarity the better (plates 1, 6, 9, 14, 21, 26, 28, 37, 39). This is probably true, but it can rarely be the case with commissioned work. I believe that you should try to know more of your model from direct experience rather than from hearsay or prejudice. If you cannot know a great deal, then I suspect it may be better to know nothing before you take up your pencil. I would suggest that, before you determine the form of your composition or the proportions of your canvas, and certainly before you make any judgement of the person, you make a number of drawings from life, doing several so that you can see new aspects of the sitter and rid yourself of any preconceived ideas of what he ought to look like. Whilst so engaged, you may learn something of the man, preferably unconsciously, from his conversation and the atmosphere between you, and as you draw, you hope for some way of sitting, gesture, or arrangement of shapes and tones, to catch your imagination and provide the basic theme for your composition.

"John"

# 2 Drawing and the problem of likeness

Ideally, the painter should be able to draw anything imaginable with whatever will make a mark. The portrait painter is subject to his model's capacity for sitting and it will be to his advantage to plan his work more carefully than ever appeared necessary at art school. The model will probably be unaccustomed to sitting for a painter and will be self-conscious and become easily tired. It will be to everyone's advantage if the first session is devoted to preliminary drawings that allow the model to have a rest every 15 minutes or so, change his position, and talk himself into a more confident and relaxed state of mind (plates 2, 27).

Quick sketches or preliminary drawings in a simple and familiar medium give you the chance to think about what you might try next. If you find yourself struggling with an elaborate portrait on paper, then you are wasting valuable hours of the model's presence, for you will have to do it all again on the panel or canvas. Under normal circumstances I can see little to recommend the practice, much advocated, of making a full size drawing and tracing it on to the final panel. Such a copying of your own work can be a deadening influence, for it can break the natural growth of a painting. I would guess that the small head and shoulders of the Duke of Wellington by Goya, now so notorious, was of necessity painted from a drawing and this might account for the doubts about its quality.

If all goes well, in an hour or so you should have evolved an idea for the composition. If not, you will be obliged to do more drawings. A change of scale can prove a stimulus and one suggestion is to draw on the actual panel in charcoal that you can dust off. It is a help to have several panels available for this purpose. If you have successfully drafted a small sketch of the composition, it is as well to enlarge this mechanically on to the panel so that you do not lose any fine balance of proportion (plates 4, 5). The old way of squaring up serves very well and you only need a few squares to establish essentials: the size and position of the head; the position of the hands for a half length; and the feet for a full length. If you plan to work from a drawing without the model, then of course a most elaborate squaring up is essential (the practice of Degas and Sickert), but if you are painting only the one figure from life it is better to confine yourself to a cursory marking out of sizes, or you will be worried by having to choose between your first drawing and the freshly observed facts.

Only now, charcoal in hand, and with a few marks on the panel to guide you, do you at last have to face up to the major problem of portraiture, that of likeness. Accuracy of drawing will take you most of the way, but to be more than adequate you will need a sensitivity of feeling and confident grasp of what goes to make the whole shape of the head different from that of all others. It is the shape of the head that establishes the likeness, and by comparison all else is mere embroidery.

It would therefore appear rational, and it is certainly the common advice to beginners, to draw the outline of the head, like an egg or a rugby football, and to place the features on that asymmetrical shape. I have never found this a satisfactory approach and prefer always to start drawing from the centre outwards, that is from the eyes. Obviously you have to make a guess at their size and so I indicate their position and their direction of gaze very lightly indeed and do not attempt to elaborate their structure but go on immediately to the eyebrows and nose, cheek, mouth and jaw. Each of these points of reference I relate to whatever I have already established, trying always to see the face as a whole and to catch the characteristic shape of the face and head. If the recognizable character of the sitter does not begin to emerge by the time I have got about half way, or if I am obviously making the head too large or too small, then I quickly flick off the charcoal and begin again. The danger is the tendency to linger and elaborate the features to such a degree that one is reluctant to destroy one's work. The charcoal will have to go eventually so it is foolish to elaborate.

Painters have repeatedly sought mechanical aids and both Holbein and Dürer are associated with the use of wire screens through which the artist can plot his shapes. The *camera obscura* and *camera lucida* could project an image on to a surface and the photograph seems to do everything. All such aids are irrelevant. I am sure that Holbein and Dürer did no better for them, probably worse, and their use is quite disastrous for anyone but the most wonderful painter.

Nevertheless, some measuring has to be done, if only by eye, but it should be kept to a minimum and used only when the proportions look wrong and you cannot think why they should. If in doubt, imagine plumb lines from the corners of the eye or the tip of the nose, or draw imaginary horizontals to establish the position of such awkward protuberances as ears. Similarly you can take the length of the nose as a standard of measurement and compare it to other distances.

The ability to 'catch a likeness' is often discussed and frequently assumed to be some kind of natural flair. Reynolds had great difficulty in catching a likeness and in his *Fourteenth Discourse* to the Academy students, made a most intelligent analysis of his great rival's success.

He said that Gainsborough's portraits '. . . were often little more, in regard to finishing, or determining the form of the feature, than what generally attends a dead colour (what we would call the rub-in or underpainting), but as he was always attentive to the general effect, or whole together, I have often imagined that this unfinished manner contributed even to that striking resemblance for which his portraits are so remarkable . . . there is in the general effect enough to remind the spectator of the original; the imagination supplies the rest, and per- haps more satisfactorily to himself, if not more exactly, than the Artist, with all his care, could possibly have done.'

Reynolds goes on to say, rather sourly and probably correctly, that anyone seeing the painting first and then the model is likely to be disappointed. Compare such charming portraits to those of Rembrandt, where the form is completely explored at every level, and they fall to pieces, but the example of Gainsborough serves very well to emphasize the primary importance of the main shape.

On this account, I would advise the painter not to place himself closer to the model than is absolutely necessary and to glance occasionally into a small hand mirror so that he can observe both model and picture isolated from their familiar context, in reverse, and reduced to a smaller scale. This minor aid can supply a fresh view of the work and reveal any basic faults that have escaped attention because of the painter's absorption in detail.

*Rosamund and Catherine*. Drawing for a conversation piece

1 *Toby, 1967* by Claude Harrison. Diluted Chinese ink on canvas. 27″ × 23″

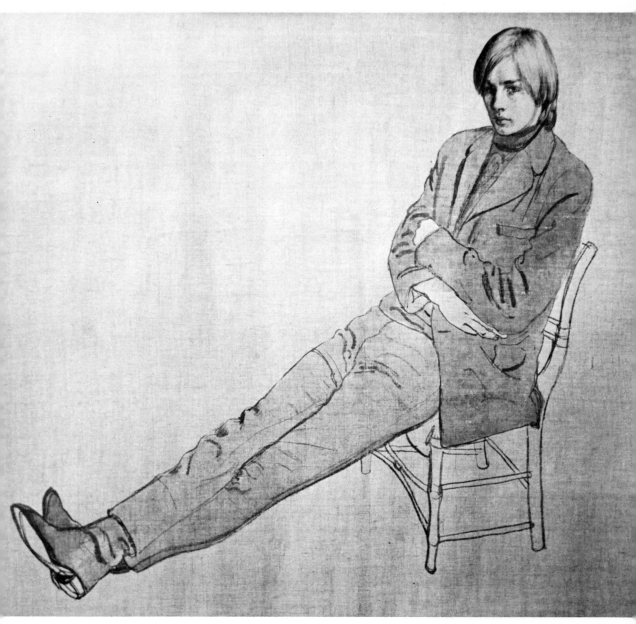

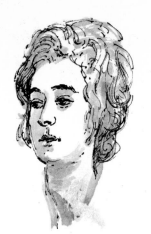
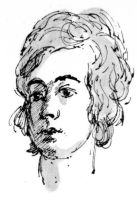
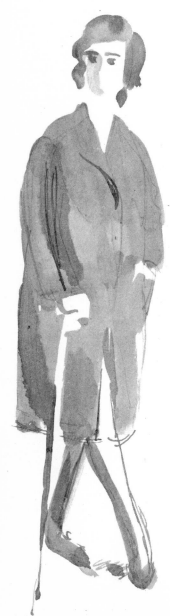
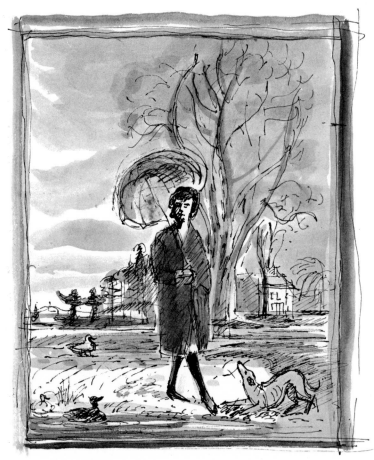

2 Preliminary drawings in pen and wash for the portrait of
Mrs Peter Sharp. The two small heads and figure on the
left drawn from life. The cartoon evolved from them
and other sketches

*Opposite*
3 *Mrs Peter Sharp, 1961* by Claude Harrison. Oil on panel.
30″ × 25″. The composition changed from the sketch
in plate 2 to allow for a larger portrait on a comparatively
small panel

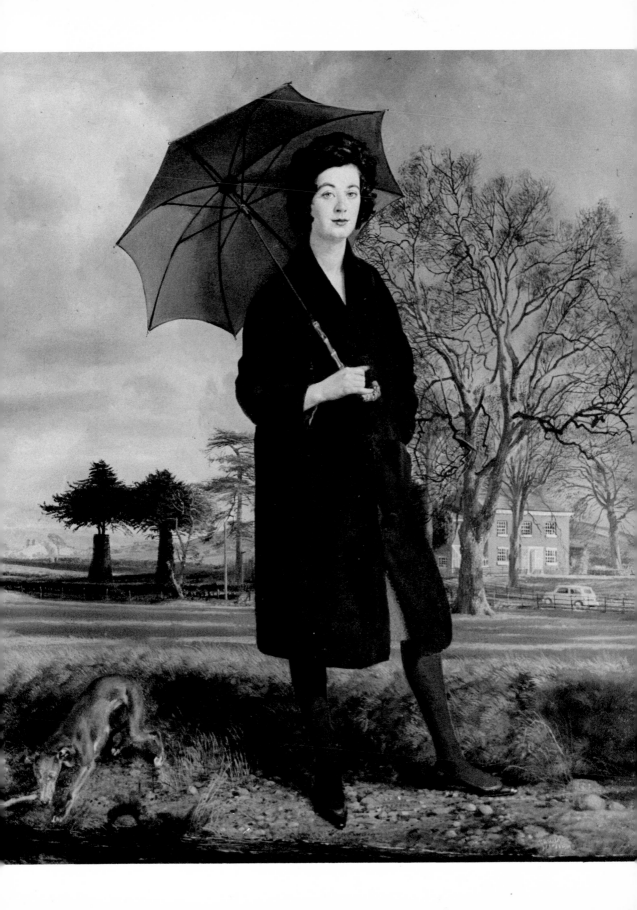

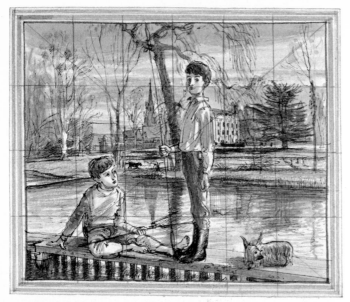

4 Pen and wash cartoon for the Puxley conversation piece. 6″ × 5″. One of several made after numerous studies from life. Squared up for transfer to the panel

5 *James and Charles Puxley at Welford Park, 1960* by Claude Harrison. Oil on panel. 30″ × 25″. All but the two boys and the Yorkshire terrier painted later from drawings

*Opposite*
6 *Toby at Easedale, 1960* by Claude Harrison. Oil on panel. 30″ × 20″. Toby painted directly from life, sitting on a table with his feet on a bench. The dog kept quiet by an electric fire

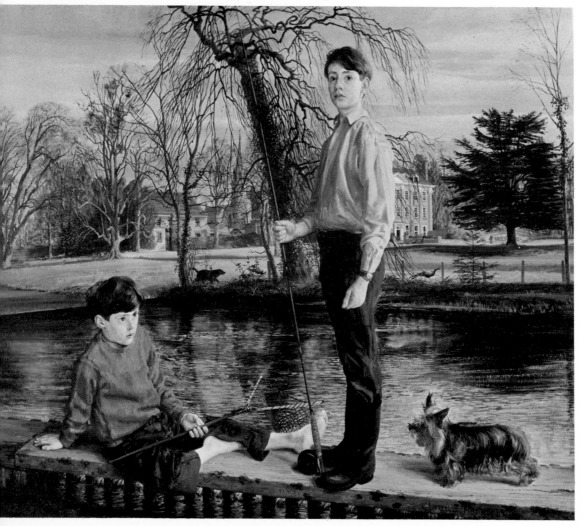

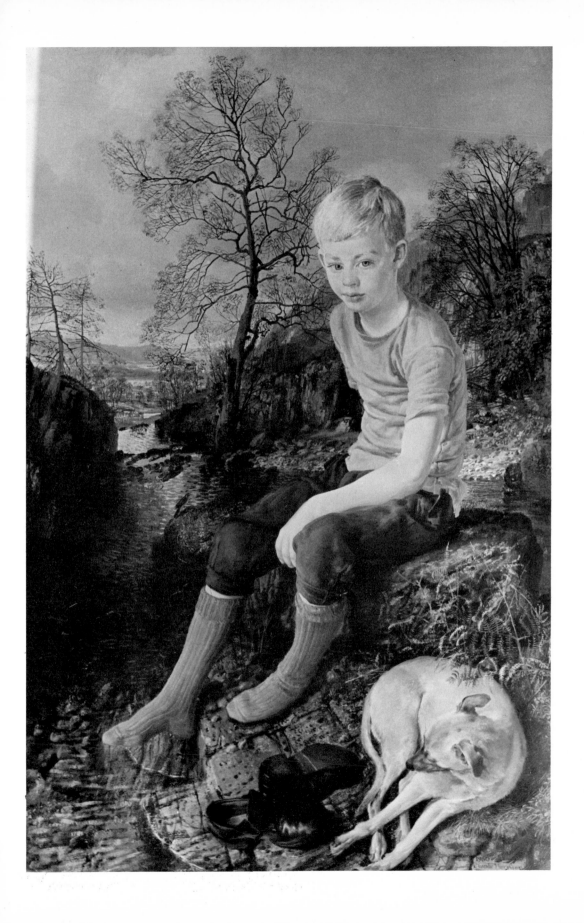

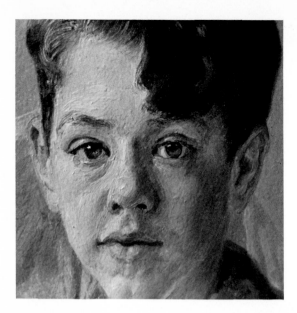

7 Detail of Peter's head. Actual size of head from top to chin 3½"

8 *Peter and Debbie on the sandhills at Birkdale, 1966* by Claude Harrison. Oil on panel. 30″ × 25″

*Opposite*

9 *Audrey by the Lake, 1967* by Claude Harrison. Oil on panel. 30″ × 16″. The figure painted from life, indoors, after innumerable drawings and discarded compositions. A few rushes and stones brought into the studio. The lake and sky from memory

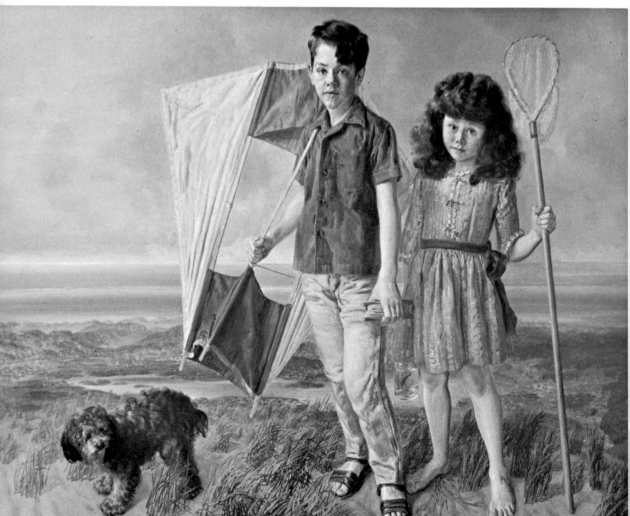

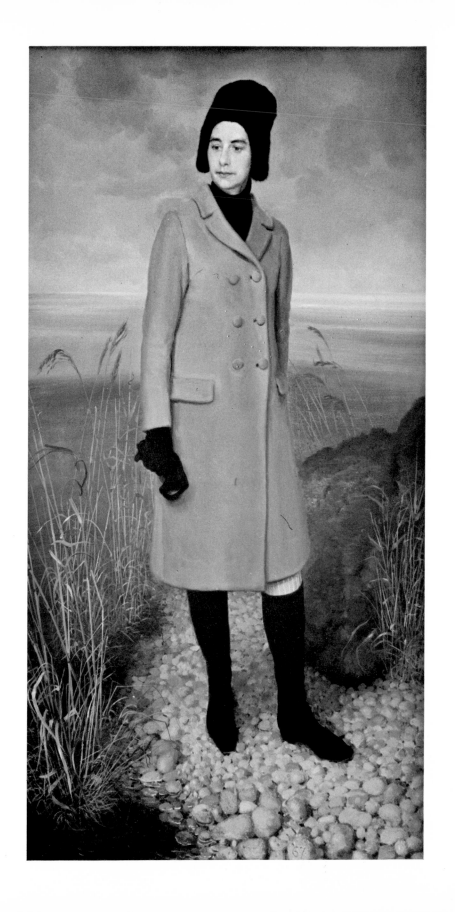

10 *Sir Francis and Lady Dashwood and their children at West Wycombe Park, 1966* by Claude Harrison. Oil on panel. 43″ × 32″

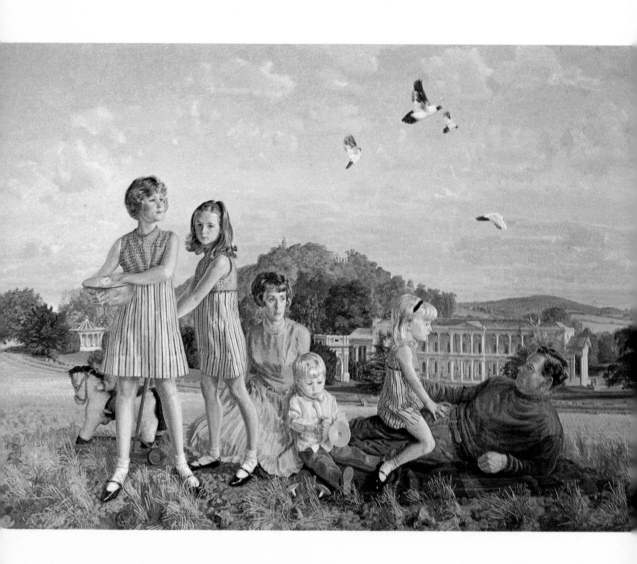

11 *The Painter's Family, 1966* by Claude Harrison. Oil on panel. 50″ × 31″. The background from memory, of a grassy seashore, peopled with a sinister group of grey people

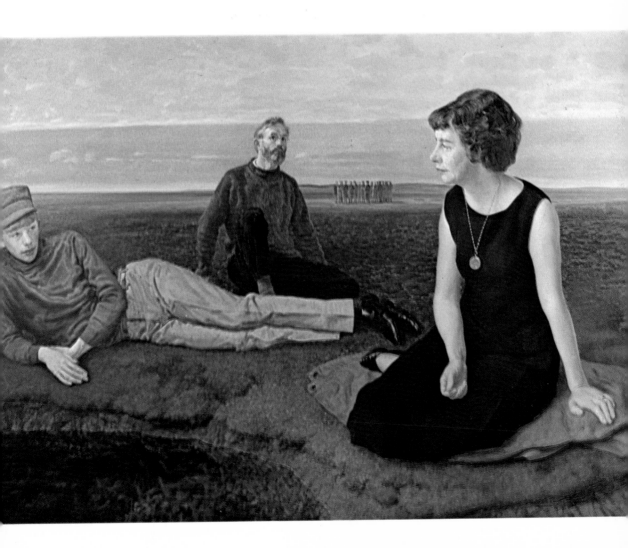

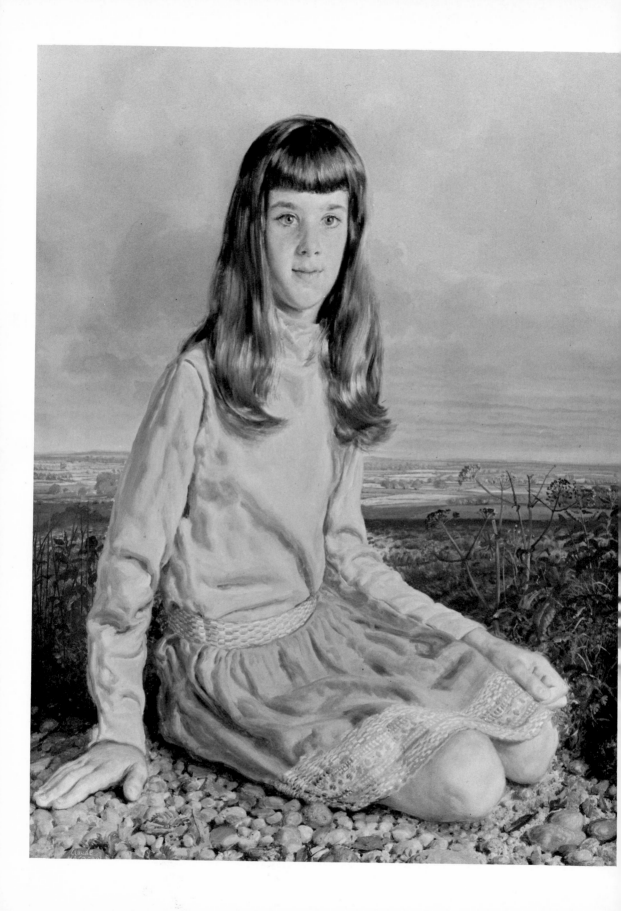

*Opposite*
12 *Deborah, 1966* by Claude Harrison. Oil on panel. 16″ × 12″. The child kneeling so that the head should be a reasonable size on so small a panel

13 *The family of Dr and Mrs Middlemiss* by Claude Harrison. Oil on panel. 30″ × 30″. The setting is a garden in Northumberland, dominated by the family toys

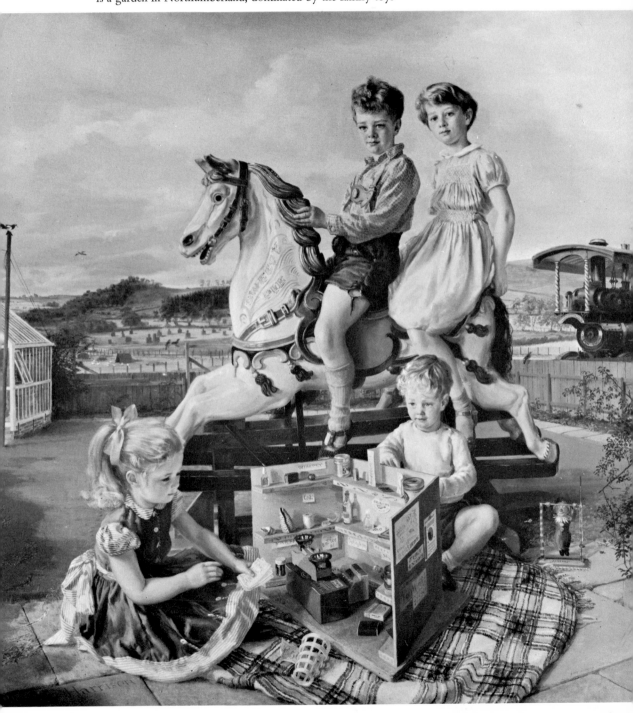

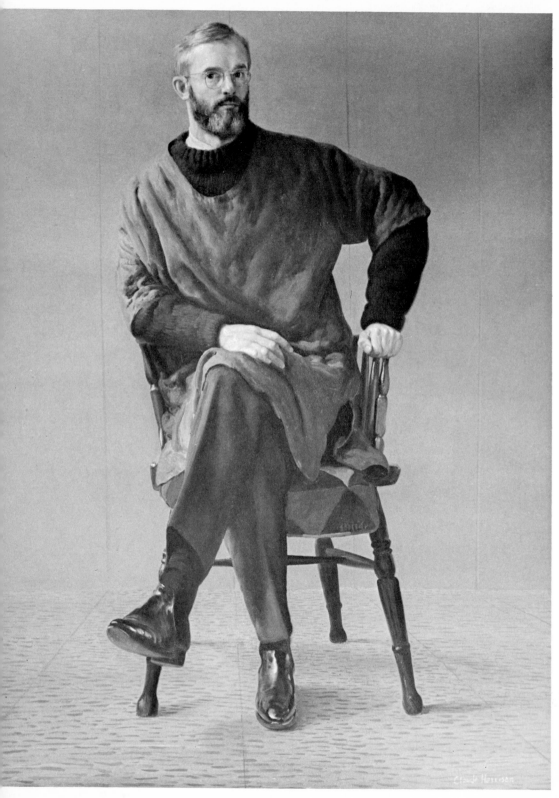

14 *Self-Portrait, 1964* by Claude Harrison. Oil on panel. 30″×25″. Painted opposite a large mirror. The hand on the right of the picture is the painting hand, which dictates the pose

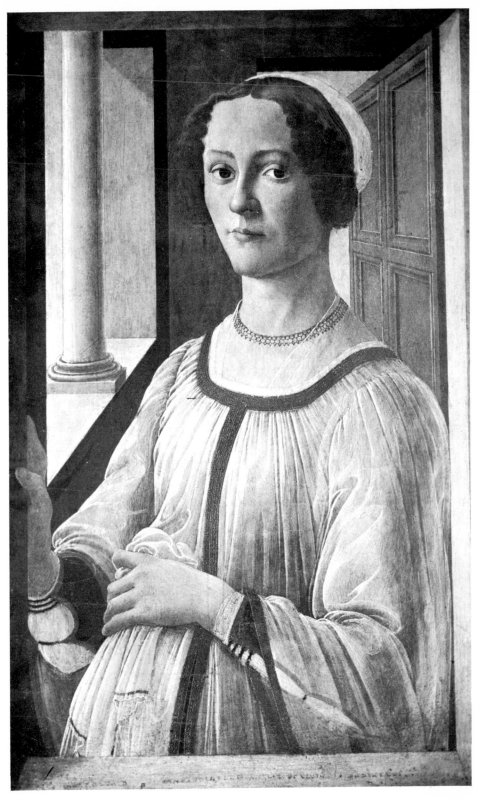

15 *Esmerelda Bandinelli* by Sandro Botticelli (1444–1510). Tempera. A precise and formal composition, exploiting the architectural perspective and emphasizing, by contrast, the wonderful reality of the head. *Victoria and Albert Museum*

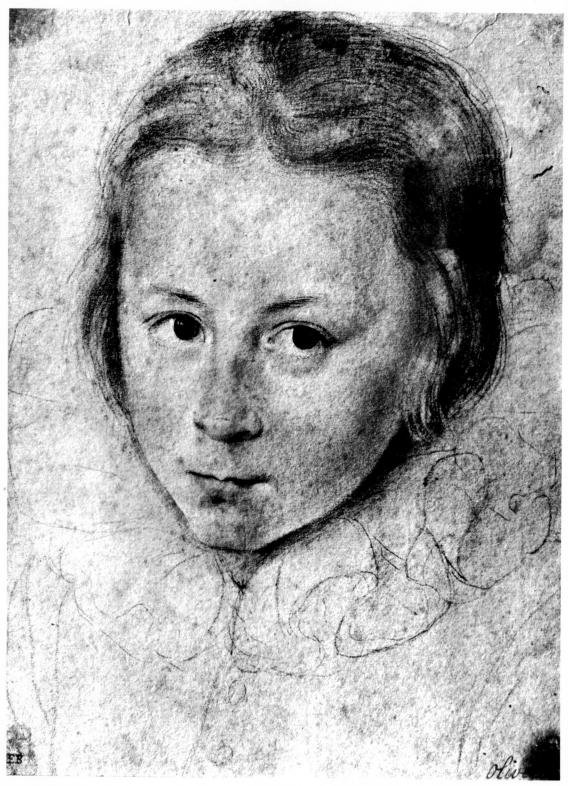

16 *Drawing of a boy* by Isaac Oliver (d. 1617). Much larger than a miniature, for which it might be the model, and so firm and true that it would be easy to reduce to the smaller painted scale. *Victoria and Albert Museum*

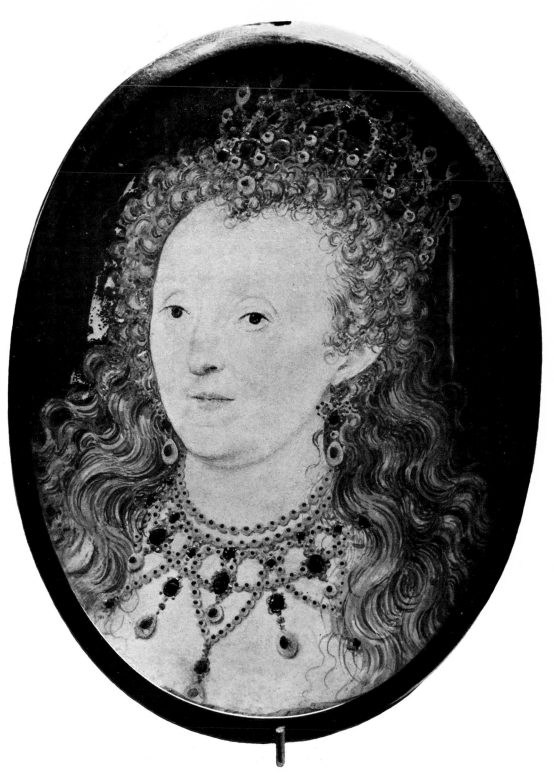

17 *Queen Elizabeth* by Nicholas Hilliard (about 1547–1619). 2¹³⁄₃₂″ × 1²⁷⁄₃₂″. Watercolour on parchment stuck to card. The round and solid forms expressed with great subtlety and all vestige of shadow determinedly rejected. *Victoria and Albert Museum*

18 *Portrait of a Notary* by Quentin Massys (1465/6–1530). Oil on wood. 31″ × 25½″. Assumed to be shown in the character of his patron saint. The design ennobles him yet the face, even the clothes, could be those of a modern lawyer. *National Gallery of Scotland*

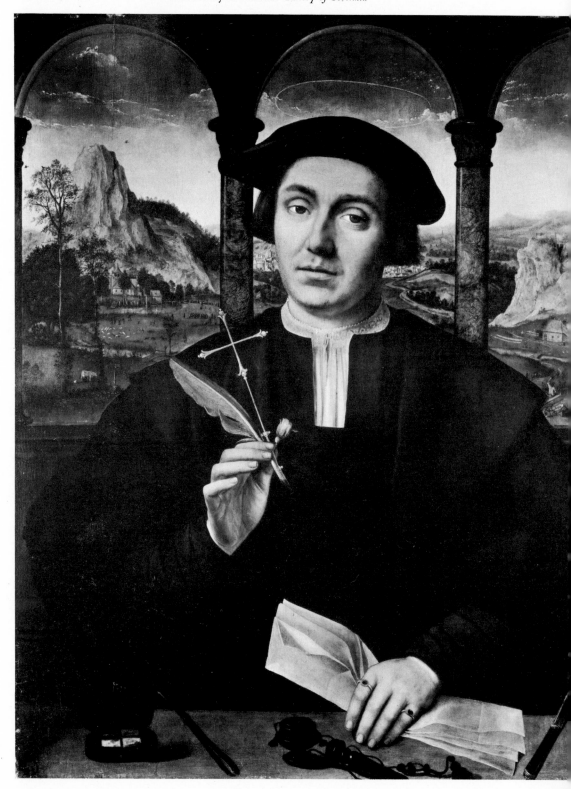

# 3 Painting the head

Broadly speaking, all that I have so far advised and described might have been said and done by any painter since ancient times. The moment paint is handled there is more conflict of opinion and I have no desire to push my way of using oil paint when a different technique might well suit the reader far better. I assume that a painter seriously concerned with portraiture would have already acquired a technique, or method of using paint, and that he would use it for portraiture as for any other subject. Nevertheless I shall describe in detail my own way of working.

A basic white ground is generally thought best because of the partial transparency of oil colours and their tendency to darken with age. You may paint directly on to this, as I habitually do, or kill its intensity with a thin film of colour. Many painters prefer to 'block in' the whole painting immediately—head, clothes and background – in colour liberally thinned with turpentine. This method certainly forces you to think in terms of main shapes and the whole rather than the parts, but it does oblige you to overpaint a great deal and to be continually correcting passages that were over-hastily established. You should pursue the method best suited to your needs, talents and limitations.

## THE RUB-IN OR UNDERPAINTING

I have already on the panel a rough charcoal drawing. I blow or dust off any excess of charcoal and draw again with a fine sable brush and a pinky brown colour thinned with turpentine. I pay no more than the minimum of attention to the charcoal drawing, but regard this stage as the most crucial. If I fail, I must wipe off with turpentine and get it right. The choice of colour should be determined by one's later intentions, for it is unlikely to be entirely obliterated until the whole figure is completed. I would expect this drawing to establish the final position of everything, but to ignore local colour and all but the simplest areas of shade (plate 1).

I do not allow the paint to have any thickness but keep it to the merest stain so that it will be sufficiently dry the next day to allow solid paint to be superimposed without danger of discoloration. I draw the whole figure like this and any adjacent objects such as a chair, and, if possible, the background. It may take half a day for a half-length portrait, a full day for a large full-length, or only an hour for an isolated head or small figure in a conversation piece. This drawing should establish the likeness and composition entirely to your satisfaction. It is quite easy to make changes later on, but a drain on the model's patience. The beginner who finds this an unnecessarily protracted start will very likely load his canvas with thick paint at the first sitting, only to realize that most of it is in need of correction,

so that subsequent sittings are frustratingly and wastefully occupied with applying even thicker layers of paint that attempt little more than the obliteration of the first coat.

COLOURS AND MEDIUMS

Only with the next stage, on top of this brush drawing, do we come to a serious use of paint, and therefore to a choice of colours and mediums. In order to make full use of a model's time, I confine myself at first to the head and I shall, therefore, speak only of the colours needed for painting flesh. As a student, I was allowed to use only four pigments: Venetian red, yellow ochre, ivory black and flake white. This was an excellent discipline for it forced one to search for the greatest variety of tones and colours. Ivory black and white could be made to look virtually blue, and the addition of yellow ochre turned it to green. Ivory black and Venetian red made quite a bright purple and variations of these three made most of the shadows, whilst the light areas were made from white, red and yellow in varying proportions. I would strongly advise the beginner to restrict himself at first to some such small group of colours if he is to appreciate the extraordinary complexity and sublety of oil paint.

This palette should rightly be extended with experience but never further than is absolutely essential. The following diagram is intended to serve as a guide for those who have little experience of figure painting.

|  | REDS | YELLOWS | BLUES |
|---|---|---|---|
| A very basic palette | Light red | Yellow ochre | Ivory black |
| A flexible palette of six colours | Light red<br><br>English red<br>(or Venetian red) | Yellow ochre<br><br>Burnt umber | Ivory black<br><br>Ultramarine |
| A palette of nine colours | Vermilion<br>(or cadmium red)<br><br>Alizarin crimson | Naples yellow<br>(or pale<br>yellow ochre)<br><br>Yellow ochre<br><br>Transparent<br>Golden ochre<br>(or raw umber)<br><br>Burnt umber | Ivory black<br><br>Ultramarine<br><br>Ultramarine violet |

In addition to the basic flake white, I would consider ivory black and yellow ochre essential. They are used in conjunction with two reds, one of which (light red or vermilion) serves for the range of orange hues and the other (alizarin) for

34

the purple. The browns serve for the rub-in and hair and the ultramarine for little else but the eyes. This list has taken no account of background or clothes, so I now list my own stock of colours. I prefer to keep no greater quantity of paint than necessary, for it can deteriorate with time and old, half-used tubes get messy. I need the largest tubes of flake white, half-size tubes of yellow ochre pale, yellow ochre, Rembrandt brown (or burnt umber), terre verte and ivory black and smaller tubes of all other colours.

| | |
|---|---|
| * Flake white | * Cadmium yellow medium |
| * Yellow ochre pale | * Raw umber |
| * Yellow ochre | Burnt umber |
| * Transparent gold ochre | * Burnt sienna |
| Cadmium yellow deep | * Rembrandt brown |
| Cadmium yellow lemon | * Ivory black |
| Cadmium red extra purple | * Cobalt blue |
| * Cadmium red extra pale | Rembrandt blue (Prussian blue) |
| * Cadmium red extra scarlet | * Terre verte |
| * Alizarin madder | Viridian |
| * Ultramarine | * Rembrandt green (chrome green) |
| * Ultramarine violet | * P. Veronese green (emerald) |
| | Cinnabar green deep |

There is a growing confusion as a result of the use of trade names by colour manufacturers and I have indicated equivalents in brackets. Asterisks mark the eighteen colours I use most frequently and I would suggest they, or their equivalents, would make up a very adequate paint box. I would be unlikely to use even half of the twenty-five colours on any one painting and for the flesh no more than six. I have chosen only to use the 'Rembrandt' colours manufactured by Talens of Holland and therefore thin my paint with their 'Rembrandt' painting medium, a solution of resin in polymerized linseed oil and a volatile mineral oil. The majority of painters thin their colours with a mixture of turpentine and cold drawn linseed oil for the first layers, and use oil for the later stages only.

PAINTING MEDIUM

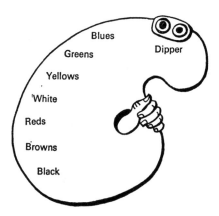

It is a help to lay out the colours always in the same order, so that you know instinctively where to dab your brush – and to have the more frequently used colours together. I usually whip up the white with medium before I start and I prefer to work on smooth panels rather than canvas.

BRUSHES

I use the largest brushes compatible with the scale of painting and begin with a short hog hair brush that will scrub the thin colour over the surface rather than lay it on, but this I soon abandon in favour of softer long ox hair brushes and large sables. On canvas, one would expect to continue with a variety of hog hair brushes but on panels they scrape off the paint rather than lay it on. Needless to say, at the end of the day brushes should be washed, with luke-warm water and a bar of soap.

THE FIRST LAYER OF COLOUR

As with the drawing, I begin each time with the area around and between the eyes, working outwards over the face with paint so thin that I can rub it over the area with my fingers and the heel of my hand. I aim to cover most of the face quickly with correct, though somewhat generalized colour, and to do this in the first half hour, or thereabouts, so that I am able to return to the centre and paint into the film of colour more decisively. As yet, I ignore the detail of eyes and mouth, all extreme lights, highlights or small variations of tone until I have established the main areas of flesh fairly accurately. This I might expect to accomplish by the end of the first hour or hour and a half. Having smoothed the paint with my fingers to ensure that the whole area is covered with colour, from now on I make no attempt to blend or rub together adjacent areas of colour, but rigidly discipline myself to lay each stroke separately. The first layer will fill any gaps and the separation of strokes into planes expresses the form more satisfactorily than any soft blending. Assuming that the face and neck have been covered during the first hour or so, I would begin again around the eyes and attempt during this third passage across the head to bring everything to near but not final completion. For reasons of clarity in the text, I now propose to describe the painting of different parts of the face, but I would emphasize that no such division exists in the task itself and one should not work too long on any isolated part of the face lest it become unrelated to the remainder.

THE SKIN

When stretched across bone, as on the brow and the bridge of the nose, the skin is often a pale cream colour, (yellow ochre, white), but the shining highlight may reflect a cold blue (black, white). The half tones may be a mauve grey (cadmium, black, white) and the shadows a warm olive (black, ochre, cadmium, white). With each plane, one has to look hard and decide: is it warm or cold, purple pink or orange pink, on the green side or on the purple side, and, most important of all, what is the tone – is it lighter than the adjacent plane or darker, and how much?

## THE EYES

I paint them both at the same time, and having already built up most of the structure of flesh that surrounds them, I begin with the 'whites'. They are usually far darker than you would expect because of the shadows of the brows, lids and lashes (black, white, a little ochre) and they are, of course, spherical and therefore lighter on one side.

On to the iris, I rub the lightest area of colour and for blue eyes this is probably a mixture of ultramarine and ochre, or even raw umber, and quite yellowish. A fine rim of hot brown or yellow usually surrounds the black void of the pupil. The outer rim of the iris is usually darker, blue or brown, or a broken mixture of the two.

If the eyes are not to squint, you must switch from one to the other as best you are able and give some thought to the direction of their gaze. Should you wish the eyes in the portrait to follow you round the room (a characteristic often remarked on with mysterious approval), all you need do is ask the model to look at your face as you paint. It might help to remind yourself that eyes are a pair of damp spheres with little holes in them, set in adjustable bags of flesh, and that they work in unison although they are not set in a straight line across a flat face, like car head-lamps, but slanting, on a sphere.

The eyelids are usually a lilac pink colour and the dark folds a reddish purple. Above this the flesh can be creamy and even greenish in the shadows of the eyelids. Lashes and highlights I leave until later, until I am sure that eyes and lids relate correctly to the rest of the face.

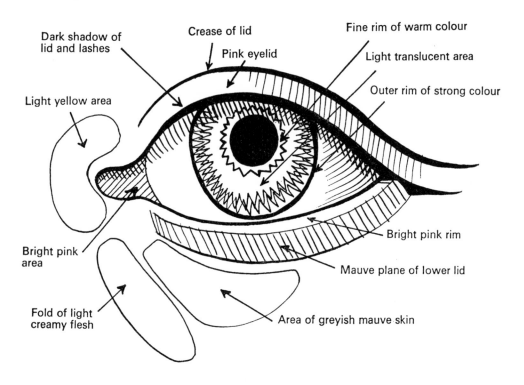

## THE NOSE

The flat planes of this essentially rectangular protuberance are usually quite clearly defined. The cream flesh pulls tightly over bone and cartilage and the pink translucent flesh of the nostrils tucks into surprisingly dark voids, but the projection of the main structure can only be adequately expressed if the tone values of the planes are accurately related.

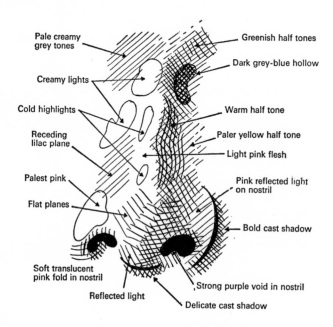

Pale creamy grey tones

Greenish half tones

Dark grey-blue hollow

Creamy lights

Cold highlights

Receding lilac plane

Warm half tone

Paler yellow half tone

Light pink flesh

Palest pink

Pink reflected light on nostril

Flat planes

Bold cast shadow

Soft translucent pink fold in nostril

Strong purple void in nostril

Reflected light

Delicate cast shadow

## THE MOUTH

This mobile slit is always the most difficult feature to get right. The most common criticism is that something is wrong with the mouth – as indeed it often is – for it isn't opening and shutting and changing shape every second. It is fatal to tell the model that you are painting his mouth, for he will often unconsciously assume the most unlikely leer, sneer or pout. You have to look out for a suitable occasion, probably when he has just finished speaking, and then quickly check the drawing of the corners, line of opening, and the edges of lips, and dab on the main areas of red half-tone in order to establish the expression at once, regardless of detail.

As with the nose, there is a contrast of surface between the soft shadowed tucks at the corners and the firm outer edges of the lips. A fine rim divides the red flesh of the lips from the rather yellow skin round about and this rim often catches the light.

The upper lip will cast a shadow on the lower and carry a certain amount of reflected light from below.

An open mouth is very difficult to paint, and teeth even more so, but should you determine to tackle such a problem, you will soon come to realize that the teeth are far from the white you might expect, for they are shadowed by a dark, purple-red cave.

For the local colour of the lips of children, or those with lipstick, I would expect to need cadmiums or vermilion, whilst for others, less fresh and colourful, Venetian or Indian red might be preferable. Alizarin and black could be used for the dark line between the lips.

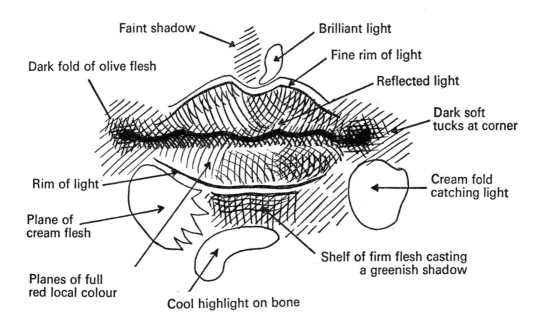

Faint shadow
Brilliant light
Fine rim of light
Dark fold of olive flesh
Reflected light
Dark soft tucks at corner
Rim of light
Cream fold catching light
Plane of cream flesh
Planes of full red local colour
Cool highlight on bone
Shelf of firm flesh casting a greenish shadow

THE CHIN, NECK AND EAR

I associate these three parts of the face because I would expect to paint them together and in relation to the face. The sides of the face are turned right away from you, except in profile, and will change tone and colour very rapidly to cool grey, and even to purple or dark green in shadow. The subtle edge of the jaw is most difficult to express, for it almost invariably receives a considerable amount of reflected light from the throat and chest and may itself cast a strong orange, green or olive shadow on the throat. The neck itself is usually very creamy, even yellow, whilst the pink collar bones catch a vivid light. The ear is a pronounced and even bright red, with deep purple shadows.

The neck is an asymmetrical column of subtle shape, and only by the most skilful attention to the changing pattern of tones that reveal the form can you express this shaft of muscle and skin. The mysterious shell-like form of the ear, designed to catch sound waves, is perhaps even more daunting for the beginner than any other feature, for he can lose his way and overstate the convolutions.

The ear sticks out and catches the light on its flatter planes, such as the lobe, and, being suffused with blood and to some extent transparent, it can glow a fiery red. You will need to analyse the structure and reduce it to a manageable set of some four tones:

1  Cool highlights of white and alizarin
2  Pink or orange lights of cadmium, white and even a little ochre
3  Reddish purple half-tones of cadmium, alizarin and white
4  Dark purple shadows of cadmium, alizarin and black

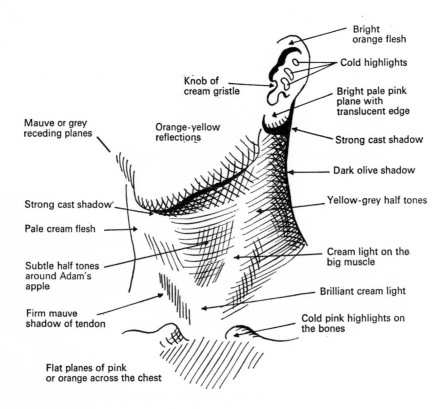

## THE HAIR

The harsh transition from light flesh to dark hair should be anticipated by first painting the cast shadows of locks or masses of hair on brow or cheek, and any areas of scalp visible through the hair.

For the hair itself, you will find the need to simplify a confused mass into some four varieties of tone and colour, reserving the richest darks and highest lights until you have more or less finished.

My practice is to scrub the darker areas on very thinly with a hog brush, wipe off any excess with my hand, and to paint into this the next lighter half-tones. You will probably observe one of these to have a bluish sheen while the actual local colour (colour without regard to chance effects of light and shade) will probably be confined to only a few small areas of lighter half-tone. The shiny lights can be dragged lightly across these half-tones with a dry splayed-out brush, and the darkest areas done last of all. If you paint the hair against a finished background the soft edge may be effected in a similar manner, but if the background is to be done later, then it will be necessary to repaint the edges with a sable brush and a thin glaze of colour.

# 4 The half-length and full-length figure

## THE POSE

The model's pose is so fundamental to the composition that it should be established before you begin to paint. For a painting of the head and shoulders, there is unlikely to be any further complication, for the model would presumably sit in a comfortable upright chair that need not be visible in the actual painting. Care should be taken to support the small of the back, and to allow the feet to rest comfortably without dangling, lest pins and needles in the legs be reflected in the expression. Softly upholstered armchairs are usually unsuitable, for they thrust the shoulders up towards the ears and encourage a slumped posture.

The half-length that includes the hands presents so many awkward problems that generations of portrait painters have embraced new solutions with such relief that each era has become identified with a stock pose, typical of the current fashionable image. The mock heroics, the conscious dignities or the elegant languors of our forebears are unlikely to be acceptable to mid-twentieth century patrons and painters. We have our own prejudices and conceits, but we must look freshly at our models if we are to do more than copy a chance way of sitting in a chair.

I would advise the painter to discuss the problem with the model so that they are able to co-operate and try the effect of different chairs, benches, stools and tables, the effects of light and reflected light, and any conceivable possibility that might stimulate the imagination. I find that most women and children will co-operate unselfconsciously and enjoy such trials, whilst men are often ill-at-ease and so afraid of looking foolish they are likely to look stuffed as they so often do in their official portraits.

## PROPORTION

The appearance of dignity and authority that men are now afraid to demand, was supplied by painters like Titian and Van Dyke as a natural and sensible convention of the time, by putting a small head on to a massive or impossibly tall body. The slightest tendency to reverse this flattering procedure will make your sitter look clownish and even pathetic, and unless you intend the effect, as you might possibly do for a comic actor, you will do well to measure the proportions of the whole carefully, using the head as module. Similar effects and distortions result from extremes of eye-level and from too close a view of the model. On the other hand, too rationalized or too accurate a representation of your sitter might preclude the very qualities you had envisaged. The generous exaggerations of Baroque painters are vital to their designs, not curious errors of scale.

## CLOTHES

Some portrait painters choose to paint the clothes whilst the sitter wears them. This may be ideal for the painter and essential for a certain style of painting, but it does demand a lot of your model's patience, probably more than they have at their command, and the folds are disturbed by every movement. You can hardly expect total immobility for any worthwhile stretch of time, or to be able to restore folds of cloth to their previous pattern after the model has rested. I usually draw all the clothing from life, at the rub-in stage, with a brush and thin colour, taking no longer over each part than the model is able to endure, and paint the clothes later, at leisure, arranged on a lay-figure to repeat as far as is possible the folds drawn from life on to the actual panel (plate 1). With a very small painting one could probably follow the first course, but with a larger and more involved painting, or an elaborately patterned cloth, the latter course would probably be demanded of you, whatever your preference.

A life-size articulated lay-figure is excellent, but expensive and difficult to obtain. Dressmakers' models and the figures used for shop window display are reasonably easy to come by and, with ingenuity and padding, can be made to serve for the more straightforward positions.

Not infrequently it is suggested that clothes should be 'dateless'. I counter any such idea with the reminder that it is usually possible to date a painting of the nude to a decade and that so-called 'dateless' garments are likely to be thought such because of their dreary insipidity. I recall the ubiquitous twin-sets and pearls of the last thirty years and the round-necked, sleeveless, three-quarter length 'artistic' dresses favoured by many painters of women between the wars. I do not say that it is impossible to paint them well, any more than a dark grey lounge suit, only that their successful exploitation might stretch even the talents of a Goya. I try to get the sitter to tell me what clothes she enjoys and feels suit her best, regardless of occasion, and endeavour to go on to consider the possible use of everything she possesses. As with posing, men are harder nuts to crack and, if asked, are likely to show you wardrobes crammed with identical suits. It is as unsatisfactory for the painter to impose clothing unsympathetic to the model as it is for the model to insist on clothes that bore the painter. Fortunately, there is at last, in this country, a genuine change of conventional habits of dress, which the painter may thankfully enjoy. One only has to recall the once fashionable and often bizarre dress of those who sat for painters like Van Dyke, Velasquez, Gainsborough, Goya, David and Renoir to realize that their very extravagance is part of the delight (plates 23, 24, 25). This 'dateless' myth seems to belong to the years between the last two wars when only a few portrait painters, like Van Dongen, exploited fashions now recalled with some nostalgia.

## HANDS AND LIMBS

These I would paint direct from life in the same manner as the head, making sure that the overall tone was sufficiently low to relate correctly to the adjacent cloth, if this still remained a pale rub-in. Hands are notoriously difficult to paint and a coherent shape should be sought before you embark on their painting. By this,

I mean a choice of position or gesture that you can understand and express intelligibly rather than a multiplicity of sloppy brush strokes that are hopefully intended to suggest a hand. Traditionally, the painting of hands separates the men from the boys and I would add to this test of skill the painting of feet, for they can be just as awkward. There is a mysterious tendency for four fingers or toes to look like five.

THE STANDING FIGURE

I would consider it excessive to ask anyone but a professional model to stand upright for the length of time required to paint all but the smallest figure. The preliminary drawings must be done this way when one need pay little attention to detail or likeness, and again the drawing on the panel and the rub-in of the body with the model standing must be done, but at this stage there can be frequent rests.

Preliminary drawing from life for plate 9

When occupied for some time with the detailed drawing of head and hands, it is usually possible for the model to lean against a piece of furniture that will allow some support without any serious change of height. When I come to rub-in, and then to paint the head and shoulders, I go to some length to arrange a table or tall stool so that the model can sit fairly comfortably at the correct height in relation to myself and as upright as he can manage. When I do this, I have to be very careful of the drawing of the neck and shoulders, if the subterfuge is not to be apparent. In the case of an elderly or infirm sitter, it would be necessary to employ a stand-in, as was common practice for most in the past, and for many VIPs in the present.

BACKGROUND

There has existed, for about half a century, an idle and unhappy convention of surrounding a portrait with daubed or half empty canvas that one can only assume the painter considers rather dashing. Such casual streaks compare badly with the deliberately planned but empty spaces that exist behind many portraits by Rembrandt and others, who convey a sense of space and air about the figure by their great skill and care in the selection of tone, colour and texture (plates 21, 22, 26, 39). The Persians and Chinese may have painted heads against untouched silk or paper, but their work is two-dimensional and gives no sense of falsity, for no illusion of depth was intended. A similar, felicitous unity applies to the flat decorative slabs of colour in a picture by Matisse. In my experience, it is rarely possible to estimate in advance the exact tone and colour of the background to the head or figure. Each time that I have attempted to do this, even with the simplest of flat areas, I have found it necessary to re-paint, usually several times, the whole of the background area.

With a painting that intends the illusion of three dimensions, it is necessary to create a sense of space behind the figure and this is more easily done by a vast panoramic scene than by a blank, for the spectator is convinced of distance by the subject matter itself (plate 18). Yet everything that you bring into the background, to help the composition or achieve a sense of space, is a potential rival for the prime motif, the portrait itself.

So considerable a repertoire of conventions exists that it would be a major feat to invent a new one, although new ones may well be inspired by ancient or neglected ideas. I list some that spring immediately to mind, to stress the importance and the possibilities of the portrait's background.

There is the architectural niche that neatly fits the head and shoulders of some mediaeval monarch as well as the more familiar saint, and the flat slab of brilliant blue used by Tudor miniaturists to show off a delicate profile. There are birds-eye views of mediaeval streets framed in little windows behind the shoulders of rich Flemings. There are Arcadian landscapes and serene skies with puff ball clouds behind Renaissance noblemen. There are the noble columns and billowing curtains appropriate to French Sun Kings and their imitators. There are mysterious voids of dense shadow and golden light that envelop Rembrandt's people, who are so real and true that you know them as you know yourself. The bland, bewigged

44

warriors of the eighteenth century have their appropriate battle scenes and the country gentry their elegant landscaped parks (plate 23). You see, from odd angles, the private apartments of the French impressionists (plate 28).

It would be presumptuous of me to do more than recall this long vista of happy solutions to remind the reader that worthwhile portraits are unlikely to result from the common practice of thoughtlessly accepting the familiar studio props of a length of elegantly folded cloth behind the same old chair.

## SELF-PORTRAITS

Even so sympathetic and ever available a model as yourself is not without some peculiar problem. Obviously you use a mirror and paint the reversed image. To correct this or to enjoy a change of view, it is necessary to use two mirrors. This takes the image so far away and so exaggerates the slightest movement that I have usually given up in despair and contented myself with a three-quarter or full-face view in the one mirror. One may readily identify self-portraits amongst the crowded bystanders of Renaissance paintings from these particular limitations. His head and eyes twist rather awkwardly towards the spectator. Only with a self-portrait can one be really free of the demands of others, free to work out what you imagine might be unacceptable to a patron, and able, if it is successful, to show as an example of what you would wish to do.

## PAINTING FROM DRAWINGS

The smaller the scale of the painting, the easier the task, as you will appreciate if you examine the chalk drawings by Watteau and the paintings where he used them (plate 29). Larger works must surely have made more direct use of the live model.

I would imagine that the striking quality of relentless precision peculiar to the famous series of drawings by Holbein, of the courtiers of Henry VIII, was dictated by his need to paint from them rather than from life, either because his subjects were too grand to sit more than once or, more probably, because Holbein foresaw the need to make copies when the original was no longer available. Holbein's drawings are made on pale tinted paper with finely pointed chalk, delicately tinted with water colour and fortified with a precise ink line wherever ambiguity might be anticipated (plates 19, 20).

The contemporary painter faced with such problems might consider photography the complete answer, but that has never been my experience, and when both drawings and photographs have been available I have found the drawing by far the more informative. The drawing should be the same size as the painting and transferred to the panel with the maximum of accuracy, by pouncing, tracing or squaring up. The first is the more accurate method. Such procedures are probably best suited to paintings in a formal style, in watercolour, tempera, or oil and tempera, rather than thick oil paint that would quickly obscure the underpainting.

The majority of the miniatures and large stylized portraits of Elizabeth I must inevitably have been done from one key drawing (plate 17).

# 5 The conversation piece

If we are to consider only the mechanics of painting, this chapter ought to be called 'Group portraiture', or how to paint several portraits on one panel, but in England there still exists a fondness, not entirely nostalgic, for the 'conversation piece'. This usually implies an intimacy of scale and setting appropriate to a family or group of friends rather than the vast boring record of a public event. The latter has rarely been handled without a sense of strain or absurdity since the seventeenth century, although a satisfactory answer to this monstrous problem may well lie ready to hand. Eighteenth century England enjoyed the happiest balance of subject and talent in the conversation pieces of Hogarth, Gainsborough, Zoffany, Stubbs and Devis, a balance due as much to the harmony of the patron's mode of life, house, park and dress as to the painter's genius (plate 23).

As a student, I despaired of ever being free of the pressure to embrace each new style of painting and I therefore sought to paint what I would like to have for myself, were I in a position to order whatever I fancied. I found myself painting small conversation pieces of my family and friends. At first I worked from memory, then from drawings, and, as the scale increased with my ambitions, from life. I had little knowledge of what had already been done and less about how to do it. I was commissioned to paint similar pictures and eventually came to regard myself as a portrait painter – particularly of conversation pieces.

As with all painting, the manner of going about such a problem should be that best fitted to the painter's temperament and style of painting. One man might find it essential to have everyone concerned standing in the correct position for much of the time and to paint them more or less directly, whilst another might prefer to make drawings and separate paintings and then assemble the final picture from those sources alone, in the calm and privacy of his studio. I have worked in both of these ways, but adopted more often a compromise that seems to answer my needs. I am conscious that it would be misguided to adopt an arbitrary pattern of work. Mannerisms and clichés abound without encouragement and most painters benefit from the challenge of unfamiliar limitations.

The first essential is to know your mechanical limitations – the size and shape of the panel, and who is to be portrayed, not to mention the fee. Contrary to popular expectations, I have usually found my patrons eager to consider my preferences and advice, presumably because they have come to me because they liked pictures of mine, and rarely have they done more than propose reasonable limitations. I like to evolve some kind of sketch design or cartoon that will show them how I wish to do it, and allow me to go ahead with their blessing and co-operation (plates 2, 4, 5). For everyone, this is the most critical stage and I begin by making preliminary drawings of whoever can most conveniently sit

Sketches for the Dashwood conversation piece, plate 10

for me. This allows me to explain my problems to the sitters, to engage their help, and it gives me time to think and look for some aspect of their mode of life that will provide material for the composition. Once I have some inkling of what this is, my preoccupations become more abstract and I am concerned with the geometry of picture making, and I need to sit with a notebook and try one thing after another until I arrive at some arrangement that I really wish to pursue. I am careful to make no attempt at likeness lest both the sitters and myself grow concerned with that aspect of the picture and fail to see what I intend for the whole. If they are not reasonably enthusiastic about the idea, I consider it wisest to scrap it and make a fresh beginning. It is better that I present them with no choice, but only with what I would want to do, even if this forces me to discard one idea after another. The major problem is to satisfy myself before seeking their approval. In the unhappy event of serious disagreement, it might be wisest to abandon the project.

I can now plan a series of sittings that allow the models to sit in rotation, so that no one is required for more than about half a day at a time. It is unlikely that everyone will be free just when I might need them, so I plan the work as best

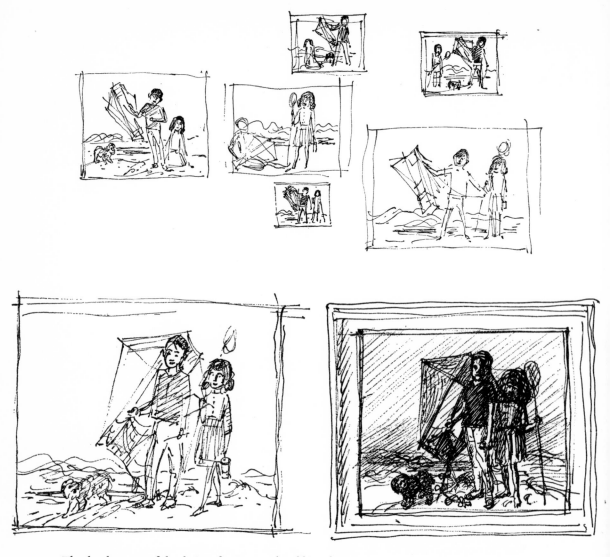

The development of the designs for Peter and Debbie, plate 8

I can and occupy any vacant hours with making drawings of the background, to work from when I come to finish the painting at home. With each figure, I follow much the same procedure as I have already described in earlier chapters, but with the considerable complication of scale and relationship. I square up my small design, transfer it lightly to the panel and draw the most important figure from life. I do not attempt to paint *in situ* for any outdoor group, for the weather and the changing light would be intolerable. I must find somewhere to work that allows me to see the models in a fairly constant light and to place them in relation to each other as they would appear in the finished picture. The first figure sets the scale for all that is to follow and I must measure each new figure against what I have already done. I therefore need to have at least two people sitting or standing

19 *William (?) Reskimer* by Hans Holbein the younger (1497/8–1543). Oil and tempera on wood. 18¼″ × 13¼″. Painted c. 1532–3. I would guess that the head is painted from the drawing and the clothes and hand from another person

20 *William (?) Reskimer* by Hans Holbein the younger. Preliminary drawing at Windsor Castle. For such elaborate studies, Holbein used red and black crayon, silverpoint, watercolour and sometimes a severe pen line

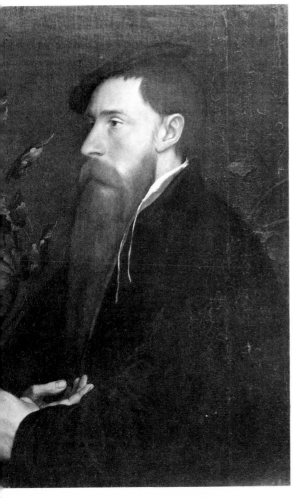 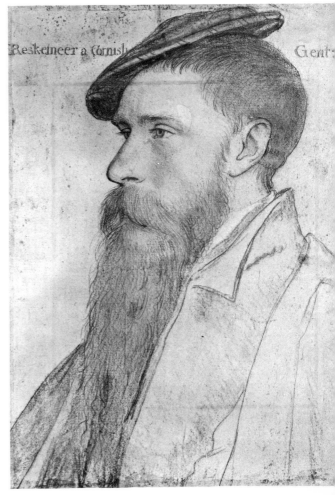

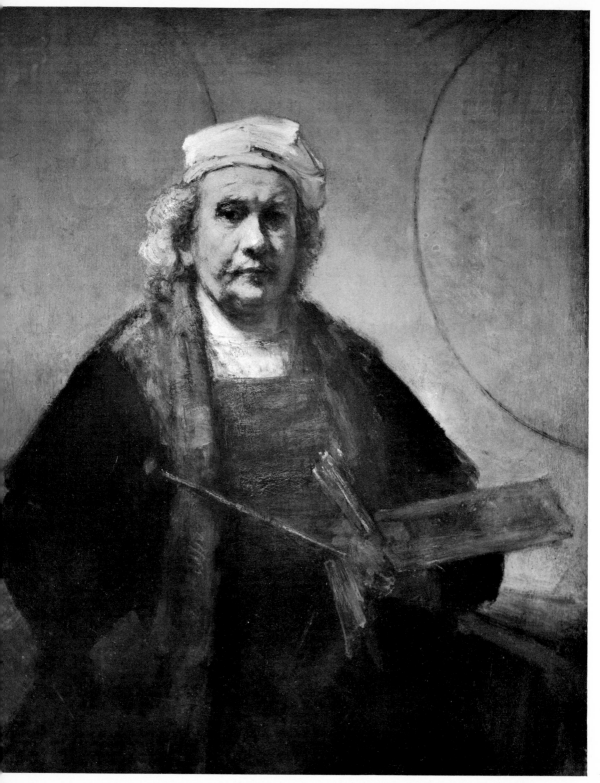

21 *Portrait of the Artist* by Rembrandt van Rijn (1606–1669). Oil on canvas. 45″ × 37″. Painted
c. 1663. Perhaps the most searching, and most revealing, as well as the noblest and humblest
of all portraits of anyone. *Iveagh Bequest, Kenwood*

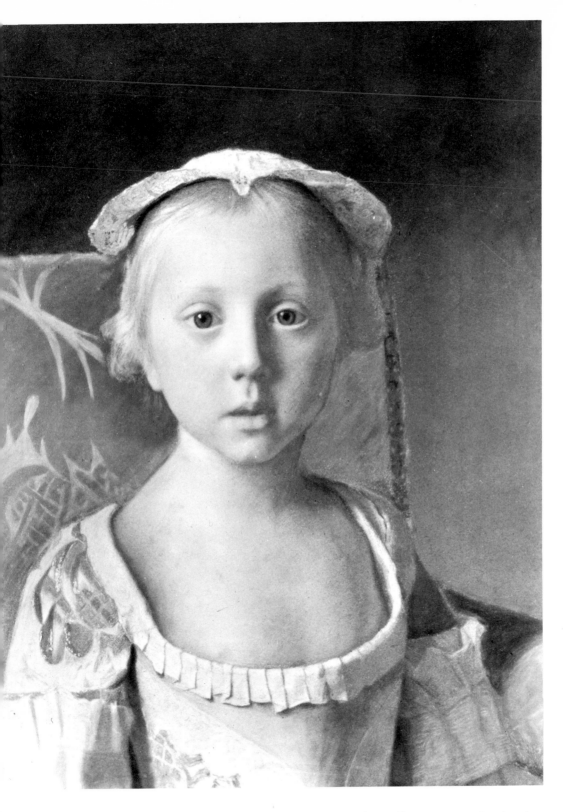

22 *Princess Louisa Ann* by Jean-Etienne Liotard (1702–1789). Pastel on vellum. 13¾″ × 12″. Pastel used like a solid matt paint to depict, with surprising candour, this very real and probably ailing child

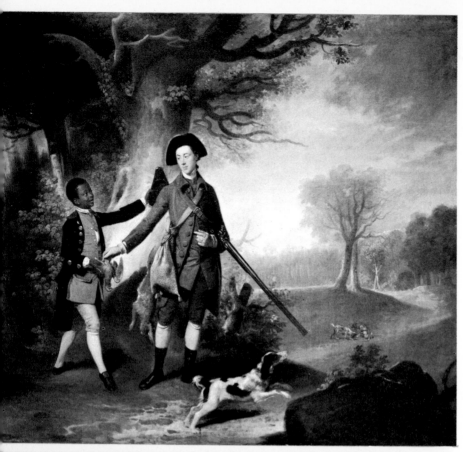

23 *The 3rd Duke of Richmond out*
   *with his servant* by John Zoffan␣
   (1725–1810). Oil on canvas. 44␣
   Painted c. 1765. *Scottish Natio␣*
   *Portrait Gallery*

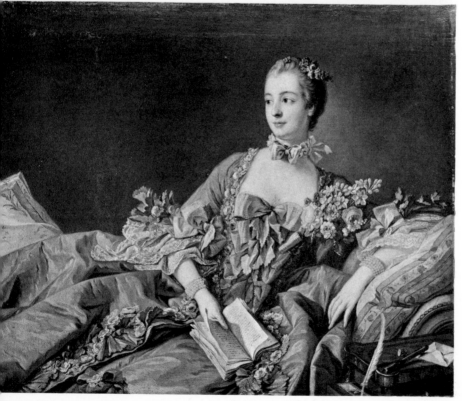

24 *Madame de Pompadour* by Franç␣
   Boucher (1703–1770). Oil on c␣
   $14\frac{1}{4}'' \times 17\frac{3}{8}''$. c. 1758. What bet␣
   picture of his mistress could a ␣
   want than this flawless rococo
   portrait? *National Gallery of Sc␣*

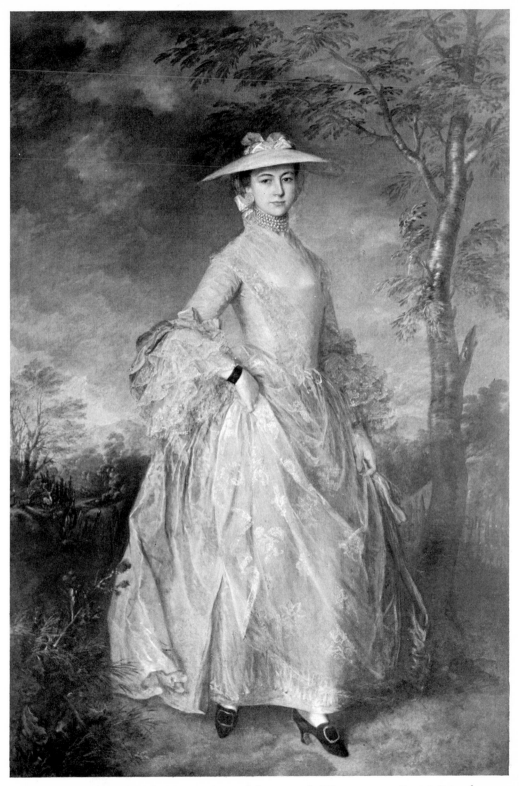

25 *Mary, Countess Howe* by Thomas Gainsborough (1727–1788). Oil on canvas. 96″ × 60″. Painted
c. 1760. Gainsborough at his best. The thin fluid paint as diaphanous as the dress, and surely a
striking likeness. *Iveagh Bequest, Kenwood*

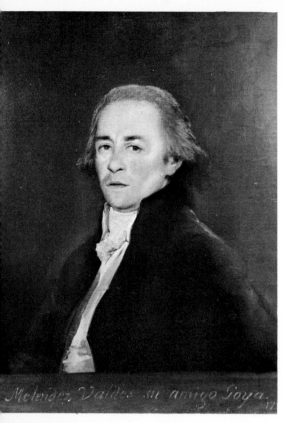

26 *Juan Antonio Melandez Valdes, a Spanish poet, 1797* by Francisco de Goya Lucientes (1746–1828). Oil on canvas. 28⅞″ × 22½″. This centrally placed bust could hardly be simpler, yet the portrait has a startling vitality. *Bowes Museum*

27 The pencil drawing (4½″ × 6½″) for the large portrait of Diego Martelli, by Edgar Degas. *National Gallery of Scotland*

*Opposite*
28 *Diego Martelli* by Edgar Degas (1834–1917). Oil. 43½″ × 39¾″. The head demands first consideration in spite of the wilful reversal of all previously accepted canons of conventional composition. *National Gallery of Scotland*

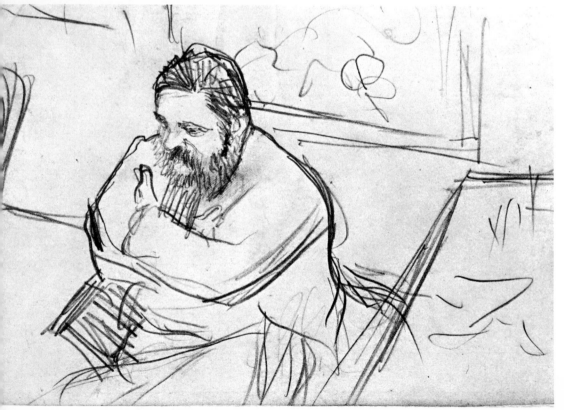

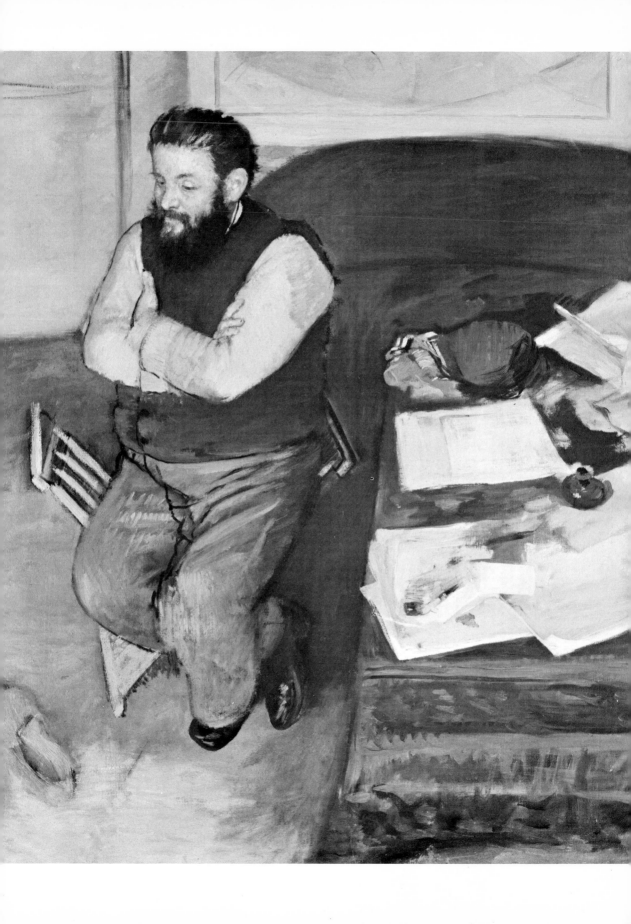

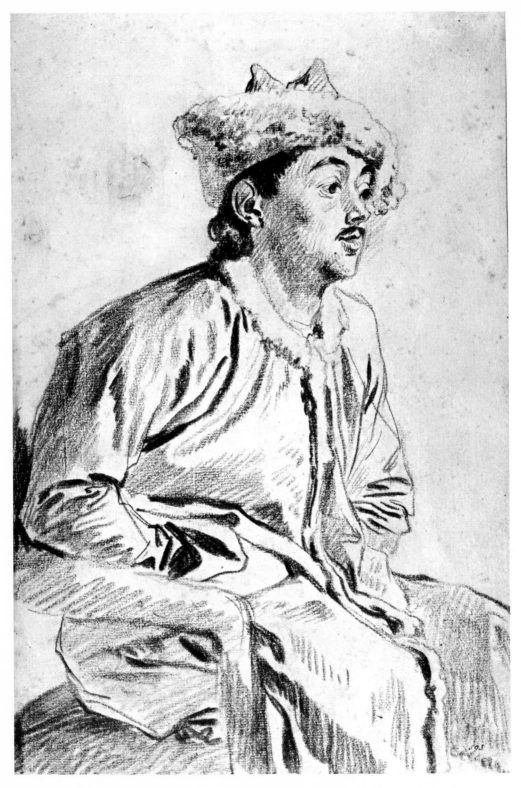

29 *A study of a man in Oriental costume* by Antoine Watteau (1684–1720). Red and black chalk. $10\frac{1}{2}'' \times 7\frac{2}{3}''$. A drawing to paint from, on the same small scale, as was Watteau's practice. *Victoria and Albert Museum*

for a few minutes in correct relationship to each other each time I begin a new figure. Obviously I must not change my own position throughout all the sittings.

Ideally, I would complete the rub-in, in monochrome, of all the figures and the background, and then go on to paint the background, behind and around them, before painting the figures. Occasionally, when everyone is available over a long period, I am able to do this, as with my own family, but when I go away to paint I find it more desirable to complete the painting of the heads and limbs there and then. I borrow the clothes and any portable props and make careful studies of the background and the setting. For a conversation piece about 30″ × 40″, with three or four major figures, I would expect to need about a week, at most, to reach this stage. When I have worked out of this country, and been obliged to complete the picture on the spot, I found that such a painting required over twenty days of work, whilst at home I would expect to spend rather longer. Although there may be considerable virtues to painting quickly from life, particularly with children, there are none that I know of concerning the whole process, except the grossly economic, and I mention these times only as a matter of general interest.

Some dangers are inherent to so complicated a task. Heads painted on different occasions from the remainder may well appear 'stuck on', like comic seaside photographs. The whole event might appear too contrived, although a certain artificiality is almost inevitable and might well prove the greater part of a picture's charm, as with the doll-like figures in a painting by Devis. I take little pleasure in those paintings of drawing rooms where the family sit around on easy chairs. The furnishings can so easily demand your first attention, dwarf the people and ruin the composition. An embarrassing hazard is that you may achieve an unacceptable variation in the quality of the different likenesses. It becomes increasingly evident to me that the composition is the key to success and if verisimilitude conflicts with design then it should be sacrificed. The colours of dresses present similar difficulties, but there is no reason why they should not be modified to suit your ends. The conversation piece out-of-doors has two major snags: how to express the middle distance, and how to master a wide expanse of bright green grass. There are traditional solutions, and answers that I do not know. A great part of the pleasure of painting lies in the pursuit of such solutions. Inevitably, both these problems can be mastered by perspective, usually by choosing an appropriate eye-level. For example, a very low eye-level will reduce the area of ground and increase the sky, a far more manageable colour, whilst objects in the middle distance may be shifted rather like the wings and flats of stage scenery (plate 25). A very high eye-level can leave you only with the immediate foreground (plate 28). Painters have never hesitated to use two eye-levels, one for the sitter and another for the landscape beyond, and when this is skilfully done we accept the result without question. Perspective is surely a useful tool, rather than a set of arbitrary laws that must be observed, and the pleasure we take in its exercise by Renaissance painters like Ucello is a recognition of their delight in its exploitation rather than an approbation of optical realities. In fact, their elaborate and meticulous observance of such laws results in a pleasing sense of unreality (plate 15).

# 6 Portraits of children

Of all my sitters, those most sympathetic to my task, patient, motionless and free of vanity, are children. Of course, very small children do not comprehend the situation and have to be entertained with some skill, but the majority regard painting as a comprehensible and worthwhile occupation, like farming, engine-driving, piracy and nursing, and they are usually prepared to help anyone who does not boss them, patronise them, or behave childishly himself. Their task is not easy and an hour must seem endless. The painter should realize this and accomplish his part of the bargain with economy and despatch. To do this, he should make no more preliminary studies than are essential, and the smaller they are the quicker they are done. Only the general shape is imperative. That must be right and the rest can wait. If the drawing is firmly established at the rub-in stage, it allows you to concentrate on the colour and tone and to carry on working after the model has ceased to hold the pose.

Babies and very small children are best dealt with when strapped in their prams or high feeding chairs. They need a succession of fascinating toys or someone to play a game and sit in such a position that the baby will keep looking in the direction you desire. It is no use telling so small a child to do this or that, and it is fatal to lose patience or reveal your frustration. You have no alternative but to lure, bribe and trick your subject into a position that will serve your ends. A nanny will quickly grasp the situation and leave you free to concentrate on the painting, and, in the absence of such professional help, an older child or the mother can manage fairly well, although occasionally the mother's presence encourages a child to misbehave.

A danger is that in their concern for your task, they lose patience with the model. I have coped alone by giving the baby a big tin full of small objects. He took them out one at a time and threw them on the floor. It took five or ten minutes to empty the tin and he enjoyed the process for about an hour.

Unless you are to see only the crown of your model's head, you will need either to raise him up or sit yourself on the floor. Teenagers are often well content to listen to long-playing records, of their own choice rather than yours or the parents', and the majority of younger children, between four and ten years old, enjoy having stories read to them. It is a trial for them to look into a bright light and a help if they can direct their gaze towards the painter, the reader or the record player. Frequent short rests, about every twenty minutes, or when the record needs changing, are better than long stretches with big breaks, and a steady trickle of sweets are appreciated by most children.

Since the end of the eighteenth century, painters have been led to exaggerate the differences of proportion between adult and child heads. The difference exists,

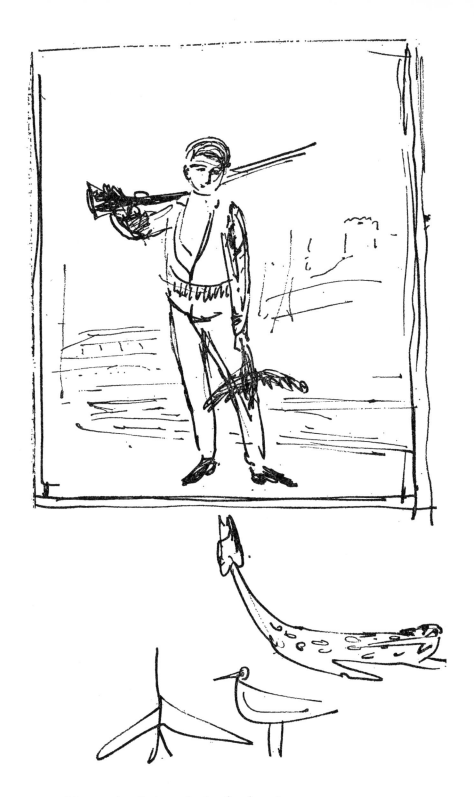

One of the several preliminary sketches for plate 36

for the child's cranium grows more slowly than the face, and any exaggeration of the under-developed character of the features in relation to the big dome of the skull will create an effect of wistful delicacy so beloved in the last century. This kind of distortion may be discerned in the later child portraits of Reynolds, presumably as a result of the admiration for Italian mannerists, and the new cult of sensibility. The effect is almost invariably enervating, sometimes coy and, at its worst, corrupt. The children in nineteenth-century portraits, in contrast to the ragamuffins in the genre pictures of the day, present an endless gallery of vapid oval faces with silly rosebud mouths, doe-like eyes and unlikely ringlets. I find this familiar and regrettable falsity tolerable in comparison to the chic perversities of the twentieth-century venality, the horrid Parisienne gamins and cute American kids. The fashionable mannerisms are so commonplace that we take them for granted and I find them so distasteful that I would say – paint children with relentless objectivity or not at all (plate 22).

Children do appear to have large tops to their heads, clear complexions, bright lips, large eyes and silky hair, and, if you underestimate these qualities, you are likely to have them looking like shrivelled old men. There is simply very little margin of error, and if these qualities are expressed truthfully, without comment or emotional stress, we recognize and enjoy them. There is a factor in child portraiture that might operate to your advantage or not for it depends on the parents' sagacity as well as your skill. It is easy to forget that a child's appearance changes quite rapidly, not only with time, but also with health and styles of hair and dress. Many parents imagine they look as they did a little while ago, and I have several times heard them comment, some months after the painting has been done, that their child has grown just like the picture. They may have come only now to see their child through a stranger's eyes and appreciated qualities, good or bad, to which their parental fondness made them blind.

From what I have so far said, it might be apparent that child portraiture enjoys peculiar hazards. It also enjoys certain privileges. The majority of children are less self-conscious than their elders and are prepared to adopt less conventional clothes and postures. They are remarkably indifferent to the effect of the finished painting, for they know the pleasure lies more in making than in possession. Their questions are relevant and factual: how long will it take and how much do paints cost; whilst their comments and criticism are as frank as they are salutary. They are accustomed by their schools to the cheerful acceptance of periods of inactive boredom and they are as yet free of the tyrannies of commerce and duty.

When I recall the paintings of children by great masters, I remember what a lot of pets were included. There were noble mastiffs as big as the noble children in paintings by Van Dyke and Titian. Goya and Hogarth must surely have delighted to paint those comic lap dogs. Their presence seems to have served as a parallel or as a contrast to their owner's way of life. Their size can provide a useful standard of measurement, and they are a malleable unit in the composition, for they can be made to occupy whatever position the painter thinks he needs, particularly in the lower half of a picture that offers nothing more interesting than the legs of people or furniture. The inclusion may well persuade a difficult child to

endure the rigours of sitting on their account. They demand of the painter the same patience and assistance as very small children, and the same objective approach. The early nineteenth-century delight in pretty lambs is notably ridiculous to our mid-twentieth-century eyes, but the animals that abound in paintings of earlier times are entirely acceptable. I do not know whether this is a permanent or even a valid criticism. Future generations may well find our preoccupation with the sordid equally ridiculous, and permanent value may depend on the quality of the mind and the quality of the painting of individual artists rather than upon the prejudices and delights of his time.

*Rosannah.* Drawn in biro as she danced about the room

# 7 The portrait miniature

Long neglected and now scorned, this kind of portraiture may well have been the only one where Britain equalled and occasionally outshone the rest of Europe for some three centuries. It developed from the arts of the book illuminator and the goldsmith. It was called 'limning' (derived from illuminating) and the first major limners in this country were Hans Holbein the younger and Nicholas Hilliard, both trained as goldsmiths (plates 17, 20).

The idea of a minute likeness enclosed in jewelry and worn as such is ascribed to the knights of the fifteenth-century French king, Charles VIII, who are said to have exchanged them with wives and lovers before joining an expedition to the Alps. It may be salutary to compare them with the tattered photographs we carried in our grubby wallets during recent wars; sad to contemplate the daguerrotypes in plush-lined frames that ousted the painted miniatures about a century ago, and sadder still to consider the coloured photographs that now successfully bar any appreciable revival of the art.

Perhaps this tragic unnecessary loss could be repaired if the fundamental limitations were recalled and the small likeness established as a part of valuable jewelry, given as a present and carried about. When they are so cheap that all might have them, and hang on walls like shrunken pictures, the art declines. Some bold talent, such as Salvador Dali brought to bear on jewelry, would seem to be needed.

I would advise anyone with the eyesight, draughtsmanship and ambition to attempt this neglected art to go, with a magnifying glass, to the great national collections, to study the techniques and to consider the implications that are so apparent when centuries of work are all gathered into a few square feet of cabinet. If he would try for himself, then all he needs to begin are the smallest sable brush, a few small tubes of watercolour, one of Chinese white and a piece of Bristol board. He may be relieved to know that the techniques to be mastered are, if compared to oil or fresco, strict but straightforward.

CLEANLINESS

On this scale, a speck of dust is a measurable object and the advice given by Hilliard in his 'Treatise concerning the Arte of Limning' is, like most of his advice, as relevant now as it was then. He says '. . . be presizly pure and klenly in all his doings, as in grinding his coulers in place wher ther is neither dust nor smoake, the watter wel chossen or distilled most pure, . . . let your aparell be silke, such as sheadeth lest dust or haires . . . beware you tuch not your worke with your fingers, or any hard thing, but with a clean pencel brush it, or with a whitfeather, neither breathe one it, especially in could weather, take head of the dandrawe (dandruff) of the head . . . and of speaking over your work for sparkling (spitting).

## PATIENCE AND EYESIGHT

The eyes need to adapt to such close work and there is a certain lapse of time before they can actually appreciate as fine detail as is necessary. It is therefore advisable to limber up like an athlete by working on some less important or alternative area before attempting the face, and similarly there is a limit to how long you may sensibly work under such strain. With sense and experience it is practicable to work without the confusion of a magnifying glass and the eyes are exercised by having to look at the model.

## SUPPORTS AND GROUNDS

The Elizabethans, Holbein, Hilliard, Peter and Isaac Oliver used oil, watercolour, gouache and tempera on such diverse supports as vellum, parchment, cardboard, metal, slate, wood, paper and bone, but not the ivory now universally associated with miniatures. The first use of ivory is attributed to Bernard Lens at the beginning of the eighteenth century, and it was immediately realized to be an ideal support for work that is essentially precious.

## BRISTOL BOARD AND FINE, THICK, HANDMADE PAPER

These are cheap and excellent grounds, particularly for gouache and watercolour and are similar to the cards used by Holbein and the Elizabethans.

## VELLUM AND PARCHMENT

The latter is a cheaper alternative that yellows rather badly. The vellum is stiffened by stretching it over a stiff white card, glueing the snipped overlaps to the back of the card, pressing between sheets of clean paper and leaving overnight under a heavy weight. Skin is very greasy and it is essential to get rid of the grease before attempting to paint. The usual method is 'pouncing' – simply rubbing the surface for a few minutes with a powdered mixture of equal part French chalk and powdered pumice. All trace of this must be removed with a cloth. Vellum is generally considered the ideal support for the opaque techniques of gouache and tempera and an examination of ancient illuminated manuscripts will certainly endorse such an opinion.

## IVORY

Sheets (called leaves) of a variety of standard sizes may be bought from the major artists' suppliers. It is usually supplied bleached or unbleached. You may prefer the natural creamy colour but, if you want it to be paler, you can bleach it yourself by dipping it in water and exposing it to direct sunlight, but secured in such a way as to prevent warping and splitting.

To trim the leaf round or oval, cut with sharp scissors across and with the grain as you would chisel timber. It is rather like cutting a big toe nail and just as likely to split. It is likely to be greasy and will need a little pouncing, preferably after you have sketched the outlines and touched it with your fingers. Because of its transparent nature, it is necessary to back it with a white card.

## METAL

Copper, silver and gold were used in the sixteenth and seventeenth centuries as supports for oil paint and, being non-absorbent, required a ground only when a colour was needed beneath semi-opaque paint. The main use of metal is to support the fired enamel, particularly appropriate to the jeweler's craft and with the same appearance and virtually the same permanence as enamel on porcelain.

## PAINTS

Naturally enough, they are the same as those used for larger work, with the exception of fired enamel, where it is essential to use a fusible medium and metal oxides.

Use the smallest tubes of paint (never use pans of colour) so that it is fresh and clean, putting out a little at a time on to a palette that can readily be wiped free of dust, such as one of white china, glass or plastic.

## BRUSHES

Only the finest sable are to be considered and the smallest No. oo is that most commonly used. Traditionally, the pin-feather of the woodcock is the finest of brushes and that you will have to acquire and mount for yourself. Experiments with other game bird feathers might prove useful. The nature of the brushes affects the painting more than any other material factor, so they will have to be good, clean and well-cared for.

## OIL PAINT

As a result of painting conversation pieces, I have had to paint a great many small portraits in this medium. When the distance from crown to chin is between two and three inches, the medium is excellent, but reduce it to one and half inches and difficulties begin to show. The shadows quickly look dirty and the brush strokes themselves cast shadows. At this point I would consider the medium to be inappropriate to the scale, and the alacrity with which the eighteenth-century miniaturists took to watercolour would seem to endorse this opinion.

## GOUACHE

These colours can now be bought in small tubes but some may prefer to use Chinese white and watercolours. The majority may well consider it wiser to draw the portrait on paper and then transfer the outline to the final support.

With the semi-transparent leaf of ivory, it is sufficient to slip the drawing underneath, but with opaque supports it will be necessary to trace the drawing with a stylus, giving a faint indentation. Pencil is to be avoided and the main outlines are better indicated with a brush and a light pinkish colour. Presumably so accomplished a miniaturist as Cosway dispensed with all preliminaries when dashing off his reputed dozen a day, and I would consider that an experienced draughtsman ought to be able to draw directly with the brush, saving time and gaining vitality.

The common practice with gouache is to lay an even coat of pale pinky white, the lightest flesh tone, over the area that is to be flesh and when this is dry to paint

the features on to it, using fine lines and a stipple. Naturally enough, this technique lends itself to the stylized shadowless 'coloured drawings' of Persian miniatures, where light and shade are ignored and a flat decorative effect is sought. At first glance, Elizabethan work looks very similar, even large scale portraits, but the western itch after reality is always there. The form is expressed by the minimum of tiny dots and strokes of colour and the faces are round ones although shadowless. Queen Elizabeth I went to some pains to instruct Hilliard to paint without shadows in a good light, excellent advice that he was in no position to refute, but more likely to result in analytical truth than the flattery she sought (plate 17).

WATERCOLOUR

This is the simplest, quickest and, therefore, most popular of mediums and probably the best suited to ivory, for the natural colour of the support will itself pass for much of the flesh. The drawing is usually established with Venetian red and a single pale wash of cobalt blue. From then on the traditional watercolour technique of washes of mixed or overlapping colours is no longer applicable for, on this scale, it quickly results in opaque dirtiness. Examination of old miniatures and a little experience will quickly make it clear that the Pointillist technique developed by Seurat at the end of the nineteenth century was long anticipated by the limners and that it is probably the best for this purpose. The idea is even more rational when applied to very small work than it is to Seurat's large paintings, since it rests upon the eye's ability to mix for itself adjacent dots of primary colours. Dots, or thin strokes, of red and blue, alternating, will read as purple, blue and yellow as green, red and yellow as orange, and so on. It is more practical to make a series of controlled touches with a fine point than it is to make a stroke and equally advantageous to use unmixed and therefore unmuddied colours.

FIRED ENAMELS

The brilliance and permanence of such painting on metal and porcelain is particularly suited to jewelry and to miniature painting, but the technical complications are so great that it would be better studied at an art school or a factory. Colours made with a fusible medium and metal oxides are used and they change colour on firing. These are applied to metal that has already received coats of powdered frit or porcelain enamel and fired in a kiln. The final picture must again be fixed by firing. This may sound rather daunting in print, but direct experience and tuition would show such techniques to be quite practical and I suspect that fired enamels, as a part of the jeweler's craft, may well be the most promising avenue of exploration at this time.

# 8 The portrait painter's materials

My experience of the ideal studio, lofty, north-lit, galleried and romantic, has been confined to sets for *La Bohème*.

Virtues of size, constant light and metropolitan glamour may well be offset by cold, monotony and cost. Bearing in mind how miserable the cold can be for a painter, let alone the model without exercise or preoccupation, it seems reasonable to give heating first priority. This means a studio no larger than you can afford to heat, not just rent, and a portable electric fire to warm the model who will feel appreciably colder than the painter, particularly if required to wear a summer dress in mid-winter.

The undeniable asset of the constant north light is to some extent offset by that very quality, so that a room with more than one aspect, and heavy curtains, will give some opportunity of variation. Direct sunlight can be controlled by linen blinds (*window shades*) or by pinning a white cotton sheet across the window frame. Inadequate light can be fought with the reflected light from white panels, disposed to the best advantage. Artificial lighting is practical enough but, in my experience, inferior to the weakest daylight. It entails some experiment with varieties of 'daylight' strips and bulbs, reflected from wall, ceiling or screen. The deciding factor is the colour of the finished work in daylight. A portrait executed in daylight will look reasonably satisfactory when artificially lit, but this is not always so when the process is reversed.

I would consider two easels essential: a solid, adjustable 'studio' type easel that will hold your picture, and a frame, to any angle; and a light folding easel that will serve for sittings away from home.

The 'model's throne' is usually a wooden box on castors, about two feet high and three or four feet square. Such an object can usually be improvised from boards, folding tables and boxes. If not, the painter may well have to sit on a low stool, or, to paint small children, on the floor. The purpose of such a throne is to enable you to see the model from below eye level, or to paint standing up. It is pleasant to have a room that passes for a studio, but not essential. Away from home, I have found it quite practicable to work with what I could carry for myself, a folding easel, box of paints, panel, and cloth to save the carpet.

PENCIL DRAWINGS
The ubiquitous lead pencil dates only from the early nineteenth century and, in spite of its obvious convenience, is probably too thin and grey a medium for most portrait painters. Nevertheless I know of few drawings comparable to the small full-length portraits and conversation pieces by Ingres in that medium.

SILVER POINT

This precise and beautiful medium was widely used by the old masters for their studies. The paper has to be prepared with a thin coat of Chinese white, which can be tinted, and the drawing is done with the point of a piece of silver wire, or solid silver, attached to a handle. The former you might make for yourself and the latter may be had from a jeweler. I can well imagine this medium being regarded with suspicion, as too precious for this era, in spite, or because of its association with the unequivocal past. Certainly some twentieth-century silver points are weak and selfconscious imitations of Renaissance drawings, but this is the fault of the draughtsman, not the medium.

CHARCOAL

Almost invariably used for the initial stages of painting, charcoal is well-suited to larger portrait drawings. I have found the thin twigs of vine charcoal the handier to use but I am inclined always to the smaller scale. Thin, hard light papers such as Michallet and Ingres take charcoal very well. Drawings are occasionally made on tinted paper with the highlights done in white and it is a dangerous temptation to overdo such heightening, so much so that I would advise that such variations of tone be confined to drawings in coloured chalk or pastel.

PEN, INK AND WASH

These basic materials are natural to our writing habits and so simple and permanent that they have remained the artist's first tool for centuries. You may draw very well with a biro or fountain pen, yet they impose stricter limitations than the quill and the reed. These you may trim for yourself with a small sharp blade. I have found Chinese stick ink better than any bottled ink. You rub it with water in a shallow dish. Waterproof Indian ink can be diluted with distilled water but it clogs the pen and is only of service for work that must be very black for reproduction. The soluble black fountain pen inks have a blue grey cast and fail to withstand the gentlest of washes. The 'Rapidograph' and similar needle type fountain pens allow the use of insoluble inks but they demand some care if they are to continue to flow, and they confine you to one line of unvarying width.

Papers should be fairly smooth and, if you are to use a wash, fairly thick. The drawings that Rembrandt made with a pen, reed or a brush and a few tones of diluted ink are probably the most profound and most beautiful that our civilization can show.

COLOURED CHALK, SANGUINE AND CRAYON

The majority of portrait drawings were never intended as ends in themselves but as preparations for paintings, either to explore the possibilities, or to make immediately a record that would later be the only source of information for a portrait to be painted without the model. For this latter purpose, it is a help to have as much information about relative tones as can be quickly noted. The choice of tinted paper gives one tone, even a colour, before you start. The loveliest and most informative of such drawings are those by Watteau and Rubens (plate 29).

You may take flesh-coloured paper, draw with a light red or brownish-red chalk called sanguine, mark the darks with a darker brown, red or black chalk and the lights with white, and you quickly record a lot of facts. Do this with the intention of making a charming drawing and you may have accomplished only a flashy sketch.

PASTEL

For portraiture, pastel dates back only to the eighteenth century, when it was used, principally in France, as a brilliant alternative to oil paint. When the colours and support are of the purest and the conservation ideal it is the most permanent of media. You can make them yourself but, as with other materials, it would seem rather laborious when they can be bought so readily. The extravagant claims of manufacturers should, as ever, be viewed with some suspicion, and I understand that the permanence of the crayons can be checked by dropping a fragment into pure spirit, which unstable dyes will colour. They are usually sold in three grades, of which the softer is the easier to use. Eventually you will use a large variety of tones and colours, but there is little doubt that it is better practice, for aesthetic rather than economic reasons, to begin with a minimum range and extend it in the light of personal experience rather than authoritative advice.

The support should have enough tooth to rasp off the particles of crayon and be supported so that it will not shake them off again. Soft drawing paper, canvas or muslin stretched to card, serve very well and the medium combines well with gouache, ink and watercolour, any of which may serve as a preliminary drawing.

The pastel crayons can be used in clearly defined separate strokes, as you might imagine Van Gogh or Renoir using them, or rubbed with the fingers into the support, shaded, brushed with short stiff brushes and smoothed until the surface resembles a bright mat oil painting (plate 22). The splendid portraits by Liotard, Perroneau and Latour exploit the medium to its full and are no less admirable than the pastel drawings of Degas.

Unfortunately the brilliant effect of pastel too often mesmerizes the artist into a familiar complacency with his result. I find this danger difficult to analyse or describe but easy to recognize. The example I most readily recall is that of Eric Kennington who made the striking pastel drawings to illustrate T. E. Lawrence's *Seven Pillars of Wisdom*. Reproduced without colour they look very fine but the effect is spoiled when you see the smart strokes of over simplified colour.

FIXATIVES

Charcoal, chalk and pastel all need fixing if they are not to be damaged by the slightest lateral touch, although they can withstand considerable pressure from above. Fixatives are disliked because they usually change the tone and colour values, although this is of little consequence with charcoal or chalk drawings. The common fixatives sold do very well for them. For a more elaborate coloured pastel something better should be used and a simple recommendation is to spray the back of the picture with milk, pure water, or very thin tempera. Alternatively, a resin solution of thirty-one grains of dammar resin in three and a half oz. of

benzine is suggested as the best by Maria Bazzi. The way to spray such fixatives with an atomizer is to lay the picture flat and to direct the fine mist well above and beyond the edges, catching drops from the nozzle with a cardboard screen. The pastel should be mounted (glued, stretched and pressed) to a card and separated from the glass in the frame by thin strips of wood or card along the edges. Unframed they can safely be stacked between sheets of shiny plastic.

WATERCOLOUR AND GOUACHE
In the west, the use of such media has been largely confined to miniatures where they play a major role and I have described this role in the appropriate section. Gouache was used in England by the eighteenth-century painter Gardner for large portraits with little success. The nineteenth-century watercolourists essayed similar extensions of their medium still less successfully and the ladylike efforts of this century discredit still further a large scale use of the medium. This is not to say that it cannot be done, for I can well imagine the successful use of such water paints for portraiture by painters such as David Jones, Kokoschka, Graham Sutherland and Matisse. It is obviously difficult and perhaps that is a good reason for trying to do it. Presumably the media should not be expected to do what could be better done with oil paint, but should seek to exploit and display their own characteristics.

The materials are so familiar and easy to buy that I can only think it necessary to remark that the paper should be of a good thick quality, stretched and freed from grease with a little ox-gall, and that the brushes should usually be sable.

The successful use of these two mediums by the Chinese and Japanese, even for quite large scale portraits, is very interesting and presumably relates to their indifference to anything more than an implied depth, and, indeed, if you imagine working in those flat terms, the choice of such media is inevitable.

TEMPERA
Tempera is paint containing oil in emulsion, diluted with water as the medium. It dries quickly, leaving a matt surface. It can be bought ready made-up in tubes, needs only water for dilution and can be used on any more or less absorbent ground. The brightly coloured and sharply defined pictures on wood panels by Giotto, Fra Angelico and Botticelli are typical tempera paintings. They painted with the rich experience of generations of studio practice and if you look at those chapters devoted to tempera in the books on artists' materials you will see how complicated a process it can be. There are enthusiastic practitioners to-day, attracted to the medium by its noble past, its stability and permanence compared to oils, and the challenge of its limitations. I turned to it myself in despair of handling the indifferent products of artists' colourmen. You need only recall the portraits of the early Renaissance to see how well it suits a certain style of portraiture (plate 15).

A tentative and economical approach would be to buy a few tubes of ready made casein or egg tempera colours and try for yourself on paper or cardboard. Should you decide to persevere, it will be obvious that such makeshift materials

are unworthy of the medium, and you will be well advised to consult specialist books. The plethora of recipes may deter you, so I will outline a possible course to follow.

The support should be rigid, and hardboard, or a multi-plywood serve very well. The ground should be a brilliant white, for tempera is semi-transparent, and it should be sufficiently absorbent to hold the colour. Gesso grounds have always been acknowledged the best and you can buy them ready prepared on small hardboard panels, or you can buy ready made-up gesso powder with instructions for its use.

To prepare your own panels (*using hardboard or untempered Masonite*) and make your own gesso:

1  Wipe the panel free of grease with petrol (*benzine or denatured alcohol*) and thoroughly roughen it with medium sandpaper.
2  Work in a room of warm even temperature.
3  Apply a thin coat of glue size (1:8) to both sides, to prevent warping, and allow twenty-four hours to dry.
4  In a double saucepan, heat one part of glue size solution (1:8), but do not boil. Into this stir one part whiting (French chalk or precipitated chalk) and then add one part zinc oxide powder, stirring well.
5  Whilst still warm, apply a thin coat of this creamy mixture to the board. Brush well in, and apply further coats, brushing in opposite directions, at thirty minute intervals. Many thin coats are better than one thick.
6  After it is dry (twenty-four hours) polish with a slightly damp cloth or very fine sandpaper and reduce the absorbency with a very thin coat of glue size or a four per cent formalin solution.
7  The usual defect is the formation of pin holes in the first coat, caused by faulty dilutions, changes of temperature or excessive beating of the hot liquid.

This procedure was recommended to me fifteen years ago by an American portrait painter. It is not easy and you will have to learn from direct experience. Faults usually show up immediately, or within two weeks at the worst.

The preliminary drawing may be indicated lightly in charcoal, or transferred from paper, but it should be quickly brought forward with a brush, using dilute Chinese ink, watercolour or very thin tempera. Allow this to dry and then cover it with a thin veil of diluted tempera colour, called the *imprimatura*. Upon this pale tone you may build with mounting layers of transparent or near opaque colours that dry quickly and pleasantly, although rather differently from what you will have anticipated. There is a limit to the weight of *impasto*, to avoid cracking, but no limit to the degree of dilution.

It is fairly easy to make up your own colours and emulsions. Mix fine powder colour with distilled water to the consistency of tube oil colours and store in screw cap jars. Yolk of egg is the traditional emulsion and you should separate this from the white and then pierce the skin with a needle. Mix this unadulterated egg yolk with the paste from your jar just before starting to paint and prepare only enough for a few hours' work. To learn how much egg to use, test by brushing on a sheet of glass. It should peel as a tough, sticky shaving. If it powders, you need more egg

and if it flakes, you need less. Equal bulk of egg to colour is the average requirement. Use only fresh egg yolk. Because it dries quickly, you will need a non-absorbent, or damp palette. A strip of wet rubber sponge will serve to keep the little heaps of colour damp. Dilute the colours with water or a mixture of water and emulsion. The marked yellow colour given to everything by the egg yolk quickly vanishes as you paint.

There are very many alternative emulsions, combinations of egg, oil, varnish and water, casein and so on, but the majority of specialists recommend plain yolk of egg and I certainly found it as good to use as the more complicated recipes, and equal, if not superior, to the ready made tube colours.

The finished work should be allowed to harden for several weeks before being framed under glass, which must not touch the paint surface. Alternatively, when hard it may be polished with a silk cloth, waxed, or varnished. Varnishing will change the relationship of colours and tones and exaggerate any transparencies, but it will, of course, protect the painting and give a most brilliant effect.

MIXED TECHNIQUES OF OIL AND TEMPERA

Tempera made with emulsions of egg, oil and varnish serve well as undercoats for oil paintings, and a number of portrait painters work in this way, particularly in America. The tempera must be hard dry and sealed with a thin coat of varnish. Upon this the oil colours are used largely as coloured glazes. To paint thickly would be to hide the underpainting altogether and lose the point of making it.

And, again, you may paint with tempera on to an oil painting, wet into wet. It is difficult to do, but allows you to obtain the incredibly fine lines that you see in the portraits by fifteenth and sixteenth-century German and Flemish masters (plates 18, 19). To get rid of the greasy surface of dry oil paint, wipe with garlic juice. Such variations of medium should confine themselves to oils and resins of the same properties, such as a stand oil dammar emulsion and a stand oil dammar glaze medium.

Considerable experiment, and a subsequent easy familiarity with such techniques, is essential if they are to be used for commissioned portraits. My own experience was that I found myself painting the portrait twice, once in tempera and again in oil and this was probably due to ingrained habits of using fairly solid oil paint. The problems were personal more than technical and I see no reason why a painter should not evolve for himself an excellent technique of mixed oil and tempera painting. The prime danger lies in the temptation to make bogus old masters.

OIL PAINT

Most portraits are still painted with oil paint in spite of its faults and it is commonplace for the subject to assume that he will 'be done in oils on canvas'. Yet the colours darken and the canvas sags at the slightest change of climate. The materials sold in the shops are rarely ideal: the colours are too fine ground in an excess of oil, to keep on shelves; mediums bear misleading or inadequate labels; additives abound and the quality of canvas varies unexpectedly. The painters are dependent

on ready-made paints for they have been weaned from any tradition of studio practice by more than a century of commercial manufacture. I consider them entitled to ask for paints of the highest quality, even if the brand is expensive, and for such paints to be truthfully labelled with unequivocal information as to their nature and use. For myself, I finally chose to use the materials made by Talens of Amsterdam rather than those made in England and, whenever possible, to make things for myself.

CANVAS

No expert speaks well of canvas, but it continues to be popular, for its attractive tooth (grain of canvas), lightness and convenience and, presumably, out of habit. For commissioned work, it should be of the best quality, linen or hemp, and be properly primed. To check the priming, bend and rub a corner of the canvas. It should not easily crack or dust off. The majority will prefer to buy their canvas already primed and on wooden stretchers, but should you wish to make up your own, the procedure below may be followed:

1 Tack the unprimed cloth evenly to the stretcher, starting at the centre of each side, going from side to side, and pulling taut each time
2 Size both sides with a good glue size. The priming must be isolated from the cloth fibres
3 Brush on two thin coats of a good quality white oil priming
4 Allow plenty of time to harden before you use it

METAL AND HARDBOARD SUPPORTS

Aluminium is an excellent support for small oil paintings. It should be reasonably thick and backed with a board to prevent dents that would be almost impossible to repair. Thoroughly roughen the surface, to get a tooth for the paint to grip, and to allow oxidization. A priming is not essential if you are to cover every bit of the surface.

The most widely used and heavily recommended supports to-day are the exploded and recompressed hardwood fibre boards sold as hardboard, Masonite, Presdwood etc. I have come to use these almost exclusively. Boards of moderate size can be had ready prepared from the art shops but a simple sequence of preparation can be followed at home:

1 Cut to size and wipe clean with petrol
2 Thoroughly roughen the smooth side with fine sandpaper
3 Apply two thin coats of white hardboard primer with a felt roller, working in every direction so as to ensure an even thickness. Do not dilute excessively
4 Using a roller instead of a brush gives the ground a fine texture that serves as a tooth for your oil paint. A brushed surface is rather slippery

A gesso ground (see tempera, page 70) is well suited to hardboard, but for oil painting it will have to be made less absorbent with size or varnish.

TECHNIQUES OF OIL PAINTING

The text books abound with puzzling descriptions for the use of oil paint, for it

30 *A Boy with Lesson Book* by Jean-Baptiste Greuze (1725–1805). A painting of extraordinary truth and sensibility by a painter commonly associated with mere sentimentality. *National Gallery of Scotland*

31 *Portrait of the Artist* by Wyndham Lewis (b. 1884). The quality of the portraiture enhanced rather than inhibited by the arbitrary geometry of this doctrinaire vorticist. *City of Manchester Art Gallery*

*Miss Orivida Pissaro* by Carel Weight, RA. The central position and sheer strength of the head allow the multiplicity of patterns to enhance rather than to destroy the subject

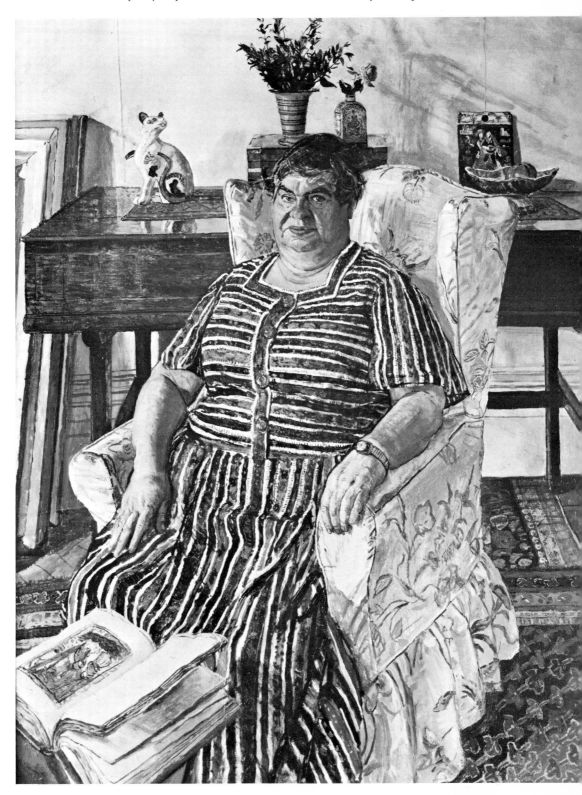

33 *Alastair Morton* by Claude Harrison. Oil on panel. 30″×25″. Detail of a half-finished full-length portrait, the head completed and the background drawn with thin paint

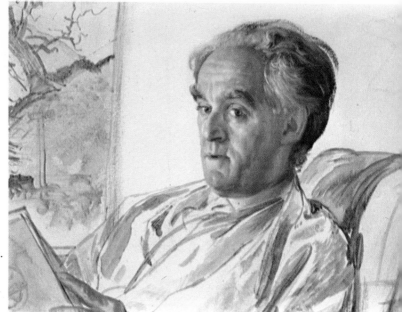

34 *Andrew and Alison* by Claude Harrison. Oil on panel. 30″×20″. The background and bicycle were painted from drawings, the remainder directly from life

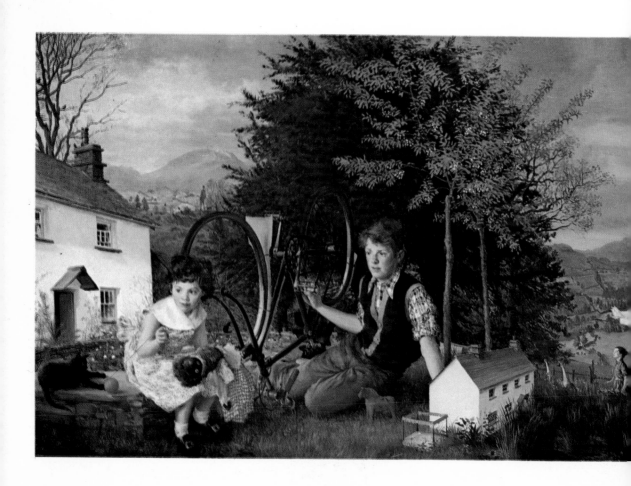

*Mark Fenwick* by Claude Harrison. Oil on panel.
30″ × 25″. The head and hands completed, the
body and gun drawn directly from life, and some
indication of a dead hare drawn in charcoal

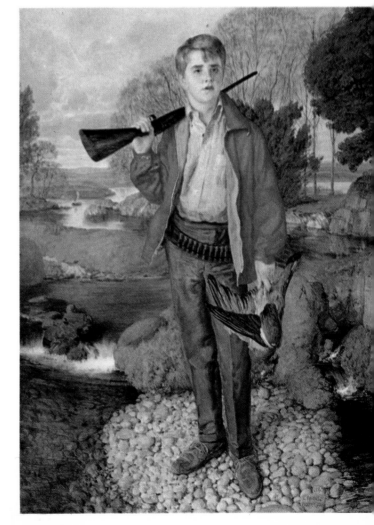

*Mark Fenwick, 1964* by Claude Harrison. The
background was painted from imagination, whilst
the gun, clothes, dead pigeon and pebbles were
painted directly from the objects in the studio

37 *Hagar in the Wilderness* by Sir Peter Paul Rubens (1577–1640). Oil on panel. 28½″×28½″. The artist's wife, painted with thin fluid silvery colours that allow the toned ground and underpainting to contribute to the finished result. *Alleyn's College of God's Gift, Dulwich*

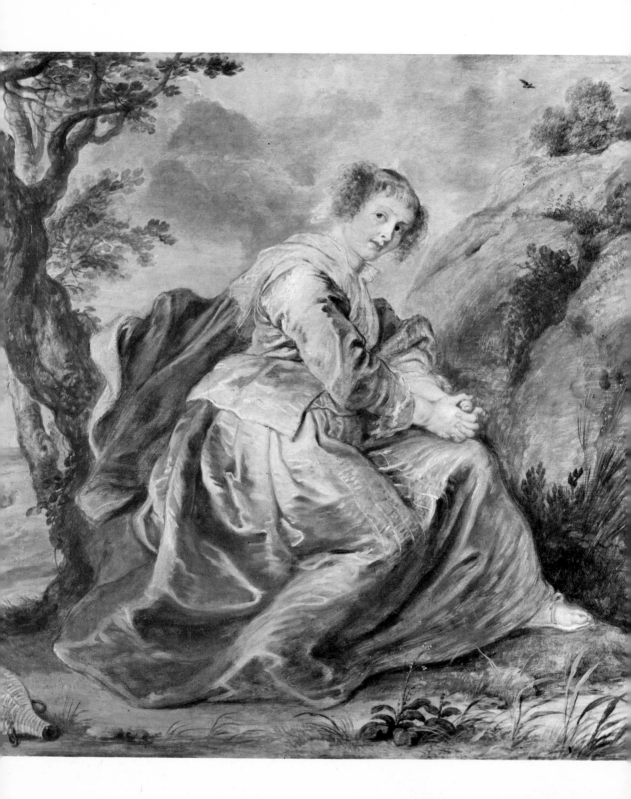

38 *A Jewish Girl, Summer, 1964* by John Bratby,
ARA. Specifically a portrait, and the whole a
mosaic of thick colours that transform
commonplace materials

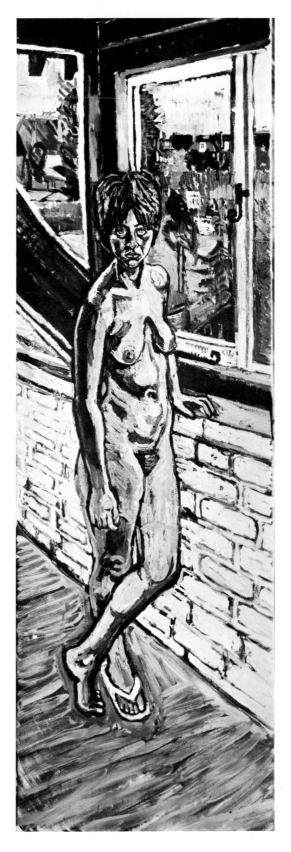

39 *Mrs Tallis* by Ruskin Spear, RA. A painting as firmly
designed, richly painted, and as unaffected as its subject

40 *Girl with a White Dog* by Lucian Freud. Oil on Canvas.
30″ × 40″. *Tate Gallery*

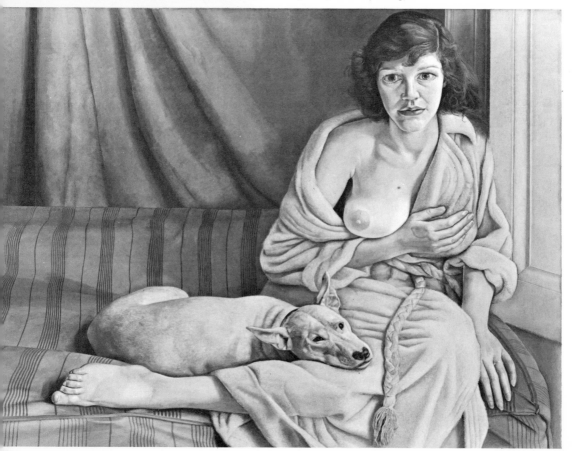

allows an astonishing variety of handling. I confine my advice, therefore, to the following modest list of generally accepted 'do's and don'ts':

1 Start lean and finish fat, i.e. dilute the first thin layers with turps or petrol and later ones with oil, painting medium or varnish
2 If you have to use siccative, dryer or retouching varnish, use as little as possible
3 Paint either wet into wet, into paint that is not quite dry, or on to paint that is entirely hardened. In the last case, you should free the surface from any grease or shine
4 Tube colours usually contain too much oil and this may be reduced by laying the paint overnight on blotting paper
5 If you use linseed oil as the medium, make sure it is 'cold drawn' linseed oil
6 Even layers of thick paint are more likely to crack than broken strokes of paint
7 A common procedure is to draw roughly with charcoal, establish this with very thin paint (diluted with more than fifty per cent of thinner) and to paint into and on to this 'rub-in' with a solid paste of colour diluted no more than is necessary with cold drawn linseed oil or a reputable medium
8 Varnish after it has had about twelve months to harden

VARNISHING

The paint must be thoroughly hard before it is isolated by varnish. Allow oil paint twelve months to harden.

For a shiny effect, choose a resin ethereal varnish such as mastic or dammar, and follow the makers' directions with care. For a matt surface, use a wax varnish. It is advisable to use on one painting one manufacturer's range of products, their ground, paint, mediums and varnish, largely because of their mystery making.

Strict attention should be paid to the process of varnishing:

1 Varnish only in a warm dry atmosphere, free of draughts and dust
2 Lay the picture flat on something that allows you to walk all round and glance along the surface
3 Ensure that the surface is free of all dirt, dust and greasiness, wiping it with water or purified petrol and drying off thoroughly
4 Gently warm the brush, the varnish and the picture
5 Use a clean old brush, wide and flat, and apply the varnish evenly and quickly, first one way and then the other
6 Look for missed patches that will show as dull gaps in the wet shine
7 Turn it upside down, resting the edges on something, and leave an hour or so to dry
8 The white film called 'bloom' caused by damp may be removed by rubbing gently with a soft paper tissue and a drop of machine oil

# 9 Professional problems

Whatever degree of skill the young painter may have, he will inevitably be concerned, even distracted, by the need to attract customers. If he fails to secure enough money for his immediate needs, he may be forced to commit himself to some form of salaried employment – usually teaching – and it is notably difficult to abandon such a regular income for the insecurity of freelance portrait painting.

I believe that a realistic and flexible plan is to accept only the barest minimum of part-time employment, or, better still, work independently at any immediately lucrative form of painting, however humble, such as sign painting or even house-painting, that may be discarded piecemeal in favour of more congenial work. Not only are you more likely to be free to deal with irregular demands, but you are, from the beginning, forced to develop self-disciplines inseparable from a free-lance way of life. The need to become sufficiently well-known to attract clients is urgent, even crucial, and the first few years of a portrait painter's career may be the most important, exciting and occasionally the happiest years of all. I am well aware of the destructive nature of a wracking poverty, but I believe that a spartan simplicity is better than a dependence on such suburban luxuries as are now commonly held to be essential. A few years without these dubious comforts are not only salutary, but a derisory price to pay for the freedom and pleasure of earning your living by doing what you want above all to do.

EXHIBITING

An old view, too often advanced, and to my mind as repellent as it is ineffective, is that the aspiring painter should attend every function and party open to him, there to persuade everyone of his merits and elicit commissions out of sympathy and goodwill regardless of his capacity to fulfil the client's expectation. People are surprisingly quick to encourage and patronize a young man of promise and just as quick to resent any failure to confirm the sagacity of their judgement. I therefore assert that the young painter would be better advised to complete a series of portraits, of himself and his family, and anyone who will sit for the asking, and to make sure that every potential customer sees these paintings before he commits himself. The painter should therefore seek to exhibit his work, rather than himself, for the most satisfactory patrons are surely those who come to him because they have seen and admired his work when they were free of outside influence or personal recommendation. Commissions arranged because a friend has persuaded a client that he will like your work are those most likely to come to grief, just as recommended holidays so often fail to please, for it is difficult for people to imagine that their friends do not necessarily share their likes and dislikes. You must needs cast your bread on the waters and stomach the insult of rejection, the necessary

expense, the proximity of works you dislike and the inevitable exposure to scorn of what you have so lovingly made. Exhibiting proves, more often than not, the most disheartening experience. If you persuade yourself that rejection reflects only the hanging committee's blind prejudice, then you must view with scepticism any subsequent approval, and grow to accept, one hopes with equanimity and ironical amusement, the taste of victory turning to ashes in your mouth.

The principal annual public exhibitions in the United Kingdom are those of the Royal Academy, the Royal Society of Portrait Painters, the Royal Scottish Academy, the New English Art Club, the Society of British Artists and the London Group. There are others of equal importance, and occasional special exhibitions, such as the John Moores at Liverpool and so on, that may be of particular value, depending upon your ambitions and manner of painting.

In the United States, the best known public exhibitions are held by such groups in New York as the National Academy, Allied Artists of America, and the Audobon Society; and by various institutions such as the Pennsylvania Academy in Philadelphia and the Corcoran Gallery in Washington, D.C. There are also a great many regional exhibitions sponsored by museums, art schools, and universities, art associations, and other cultural groups in each of the fifty states.

Local exhibitions and even the smallest local event should merit consideration for you can hardly anticipate where or when your work may catch the eye of some present day equivalent of Ruskin or Lorenzo de' Medici. It could be argued that you will be judged by the company you are seen with, but I have some doubt about the truth of this and prefer to hope that even the moderately discerning public are free from such vulgar prejudice. You may gain some foreknowledge of what is available from a study of the various art magazines and, for a moderate fee, you can have advance notice of all major exhibitions from an organization called the Exhibitors' Aid Service at the Art Exhibitions Bureau, 6½ Suffolk Street, London, SW1. Delivery of work can usually be arranged by the major frame-makers and artists' agents, of which the best known is probably James Bourlet and Sons, at 17 and 18 Nassau Street, Mortimer Street, London, W1. You may well find it easier and cheaper to take advantage of their services than to arrange everything for yourself.

The major American juried exhibitions are announced in advance in the pages of the magazine, *American Artist*. In many important American art centres, there are trucking services that specialize in delivering works of art with maximum security. I suggest you call your local museum for a recommendation.

Local picture framers will often allow you to exhibit a painting in their shop window and, quite rightly, expect to have in return the work of framing, your custom, or, less often, a percentage of your fee.

The Royal Society of Portrait Painters charge a commission of fifteen per cent on any work arranged through their Society, but the Royal Academy and some of the public galleries make no charge. The majority of public exhibitions charge a commission of ten per cent on work sold, but are unlikely to be concerned with portraits commissioned as a result of their exhibitions. Private galleries used for one-man shows will almost certainly charge at least fifteen per cent and expect

the painter to pay the rent, the attendants' wages, and the cost of catalogues, publicity and entertainment. Most private galleries are unwilling to be bothered with the complications of arranging portrait commissions, but there do exist, both here and in the USA, certain commercial organizations devoted entirely to that purpose. They advertise themselves too well to require any help from me and their services and claims merit the same careful scrutiny as do similar agencies for the sale of goods traditionally marketed in a manner that is legitimately concerned only with financial gain.

My own experience has been that the majority of commissions, over eighty per cent, are arranged directly by people who know my work because they have seen it in public exhibitions and private houses. The remainder comes through societies and agencies whose charges are entirely reasonable. I prefer to sign no contracts, or engage myself to any one gallery or agent, although I realize that a good agent could well prove his worth many times over. The problem is to know who is a good, trustworthy agent, and such decisions must inevitably be left to the painter's own nature and, as like or not, to chance.

It should be borne in mind, when choosing what to exhibit, that the majority of hanging committees are more likely to favour work that has been done for its own sake rather than obvious samples of a tradesman's wares. Their first duty is to the exhibition, not to your pocket, and I hope that I myself would choose an interesting and honest painting before a conventional or fashionable portrait of a pretty girl that obviously aims to attract custom. It is the painter's misfortune that an incredibly large proportion of otherwise intelligent people will choose to employ a painter who exhibits pictures of people whose physical appearance they find especially attractive. Yet they can rarely know whether or not the paintings are good likenesses, and they are likely to be disappointed when the resulting portraits of themselves differ from their imagined picture of themselves imbued with characteristics they so much admired.

FEES

I am unaware of any generally accepted scale of fees relating to portraiture and assume the matter to be governed by the crudest principles of supply and demand. You ask the least or the most you dare according to your nature and circumstances.

Some would argue that the public is likely to accept the worth you accord yourself, yet an unknown painter who asks an extravagant fee may be justly thought to display more effrontery than talent, and it may seem more intelligent to relate fees to the time you have available rather than to private dreams of fame and fortune. If you have but few commissions, then you might ask a fee that you suspect would tempt a vacillating client, but if you have more work than you can comfortably accomplish, you should certainly increase your charges just enough to reduce the numbers to manageable proportions. Without long experience, during a period of stable economy that we are unlikely to experience or without a rare natural flair for financial prognostications, one is unlikely to do more than make a hopeful guess and attempt to redress the balance at the next opportunity. Another piece of well-worn advice is that the higher the fees, the more clamour

for your services, and it is possible that so dizzy a condition exists for those who have acquired, from merit or luck, a notorious popularity.

I cannot possibly say what an unknown painter should charge, or a successful one, but I can outline some of the factors he should bear in mind. One is that the cost to himself of executing a portrait – his overheads, materials, rent, heat, transport and so on, including moderate taxation – is likely to account for at least half the total fee he receives. This can only be calculated on a year's work, and such a sobering calculation will be eventually demanded of him by the taxation authorities, but it is of little concern to the beginner who must attract work at any cost, and who would be only too glad to qualify for taxation. Whilst the prospect of only a month's assured income might unnerve all but the most debonair, a list of orders that will take more than twelve months to execute is likely to be something of an embarrassment. I have experienced both these conditions and I try to establish a balance, as far as I am able, of between three and eighteen months work, so that I look on about nine months of work ahead as a healthy and manageable situation that will allow me to spend about three months of the year on whatever I have a mind to paint for myself. Apart from embarking on some drastic system of self-advertisement, you can only control the situation by using the clumsy and usually belated device of changing the fees.

Except in the case of work that I do for my own pleasure, such as portraits of friends, I would regard it as the more honest professional or commercial practice to ask the same fee of all who enquire, and to keep any agent informed of my current charges. For similar reasons, it is always wisest to make sure that your client knows from the start, preferably in writing, not only what fee he will be asked when you deliver the picture, but also what is included, such as travelling expenses or framing. The cost of framing is usually met by the client for it can vary a great deal, but the majority are usually relieved to have the painter's advice and assistance. I do not charge travelling expenses unless more than two or three journeys across this country are involved. Travel overseas, hotel accommodation or extra journeys for the convenience of the client rather than on my own account I would regard as legitimate extra charges.

BOOK-KEEPING

Budding painters will soon come to realize, with justifiable dismay, that even a modest success involves them in all the complications of accounting and taxation, as does any kind of business venture. Unless they are clever enough to act for themselves, and very few can be so well-equipped, it is essential that they engage the help of an accountant, preferably one they like personally or believe to have a sympathetic interest in their work. He will be able to instruct them in whatever system of simple book-keeping he requires for his audit, and he will need from them a complete record of all their expenses and business transactions. With the painter's co-operation, he should be able to ensure that no more is paid in tax than is legally due and that they have a full understanding of their financial situation, their assets, liabilities and so on – so that they can know just how much they can afford to lay out on travel, rent, insurance, exhibitions, materials, savings

and, in fact, everything, for when there is no monthly salary to rely on they must either plan well ahead or live in a state of permanent vague apprehension. This may seem a boring and mundane subject, outside the terms of reference of this book, but the realities of money and taxation are inescapable and have to be faced one day by everyone. I believe the outmoded romantic view of the artist as a hopeless man of affairs to be quite unfounded, and that he is as likely to fail or succeed with his money as any other man, whatever his mode of life may be.

PHOTOGRAPHY

A photographic record of a painter's work is so useful that it must now be considered an essential, although rather tiresome, expense. Apart from its value as a record, it allows the portrait painter to show a prospective client, in a conveniently portable form, all that he has accomplished. A painter who has both the skill and the elaborate photographic equipment essential to making good black and white photographs enjoys a considerable advantage, for the task can be more difficult, inconvenient, time consuming and expensive than at first imagined. A little experience will soon reveal the limitations peculiar to photographing the flat, although subtle, surface of paintings, and the difference between amateur, or even local professional work and that done by specialists is great enough to warrant the extra cost and inconvenience when pictures of some importance are concerned. This applies more to black and white prints and to colour prints than to colour transparencies. If the first of these are needed for block-making, strong, shiny black and white prints will be necessary. When the prints are required only to show directly, the softer sepia prints with a matt surface are the more sympathetic translation of the original paintings. Colour prints, as distinct from transparencies, present similar difficulties and are rarely true to the real colours. Fortunately the standard of processing colour transparencies is now remarkably high and uniform, so that, by using a reasonably good camera, on a tripod, the amateur can expect to take his own. Any description of the refinements of impedimenta and expertise are outside the subject of this book, but some limitations peculiar to photographing paintings are relevant.

The lens of the camera must be aligned exactly on the centre of the painting. Failure to do this accurately will result in exaggerated distortions that would hardly be discernible were the subject asymmetrical or three dimensional. For the same reason, the picture should be exactly vertical and the camera level. These requirements oblige you to use a firm adjustable tripod. Bright daylight, from one side, is usually preferable to direct sunlight or artificial light. The last demands elaborate adjustments to avoid variations of intensity, reflection and glare. A great deal of wasteful repetition is avoided if you establish a good place for doing the job, mark out the floor with distances at right angles to the plane of the picture, and stick to those conditions of lighting and position that give the best results.

The proportions of transparencies are unlikely to match those of the paintings exactly and you will be obliged either to omit parts of the picture or to include the whole, framed, against a suitably discreet background. Copies made by the

manufacturers are dearer and less distinct than those you can obtain yourself by repeating a number of shots, assuming that you are sufficiently experienced to be confident of success.

POSTHUMOUS PORTRAITS

Under most circumstances, one can justifiably refuse to paint a portrait from photographs. Impatient clients are quick to suggest a practice that will relieve them of the tedium of sitting and ensure a familiar likeness, but painters who allow themselves to be persuaded to work from photographs will soon find themselves dependent upon the mechanical aid, their powers enervated, and their work no more than a superficial record of what everyone can see for themselves. When the subject is dead, the painter may be forced to rely on what chance records and recollections remain, and be obliged to accept the job out of sympathy or pressing need. In this situation, he can never have enough information and the enlarged image of a good colour transparency is probably the closest thing to reality, but even here the shadows are usually no more than dark voids and the painter should endeavour, from experience of painting from life, to do more than merely copy the photograph on to his panel. Unless you have known the subject well yourself, you remain at the mercy of those who have, and you are obliged to accept their advice, and to adopt their suggestions, so that you come to feel no more than a helpless tool in their hands. But, if the subject is long dead, and you are asked to reconstruct a portrait from old paintings, engravings, or, best of all, sculpture, then the whole situation is altered in your favour. The power is again in your hands and the task changed from one characterized by a feeling of helpless misery to a search for some quality that you might eventually find for yourself by research, comparison and the power of your imagination.

FRAMING AND HANGING

Although the client usually pays for the frame, and therefore enjoys a power of veto, the painter is almost invariably asked to suggest a moulding, or to see to the business entirely. I assume that he would rarely be quite unconcerned with the framing and that he would more often prefer to dictate exactly what is to be done. Some are able to design a moulding and insist that it be used, but surprisingly few painters enjoy such ability and authority, and even fewer frame-makers are willing or able to make up special mouldings. A variety of finished mouldings are now mass produced and used by almost all the frame-makers, except the specialist firms in London. Such mouldings are simply cut to the right size and glued and nailed together. They are standardized, ready-made, often over-smart and assembled in a rough and ready manner. Yet, in spite of all this, these mouldings are not very much cheaper than the properly constructed frames still made by craftsmen in London. The difference in quality is immediately apparent and results from the method of construction – the gesso, colour and gilt being applied after assembling the bare wooden frame. The frame separates the picture from its surroundings, which may be as plastic and mass produced as you like, but it is related primarily to the picture and should share with paintings executed in

traditional materials certain qualities that are essentially organic and craftsmanlike. Certainly, the painter who makes up his own frames will quickly learn a sense of what is good framing.

In my view, this harmony between frame and picture is destroyed when a modern painting is put in an antique frame, and vice versa. I am familiar with the attractive sensation of contrast achieved by putting a Picasso in an ancient worm-eaten Renaissance frame, but I have come to find the practice distasteful, and I believe that it will eventually be regarded as a ridiculous vogue inspired by the fashionable tastes of interior decorators. The problem crops up fairly often in my experience, for a large proportion of portraits must be expected to hang, with their ancestral fellows, against older walls, and amongst antique furniture and paintings. The client almost invariably suggests that an antique frame be used on this account, and when I have been so foolish as to allow this to happen, I have been bitterly disappointed, not only with my painting, but with the general effect on the wall. A close analogy can be observed when imitation eighteenth century fireplaces are installed in modern flats (*apartments*), or long, low, modern fireplaces in tall Victorian rooms. The simple rule that I deduce from all this is not that modern pictures are unsuitable amongst antique furnishings, where the contrast can be stimulating, but that the frame should match the picture.

You may appreciate the importance of this if you call to mind the magnificent effect of an Italian Renaissance painting in its original carved and gilt frame, set against the stark walls of a good modern gallery, or the equally pleasing contrast when a sharply abstract painting, framed only with a simple band of gold or white, is hung in an ancient richly textured setting.

Where a picture hangs can be severely limited by the position of the windows, for, if the source of light is directly opposite the picture, even unglazed oil paintings will be marred by the glare of reflected light. Ideally, the light should come from one side, or from above or below, and this can now be effected by strip lights attached to the top of the frame, concealed spotlights, or a table lamp below the picture. Nevertheless, daylight remains the better light. I dislike to see oil paintings under glass and would prefer them to be exposed to danger and dirt rather than have them for ever half visible behind a glass barrier that reflects more of the frustrated observer than it reveals of the picture.

# 10 The relationship of painter and patron

If we look back down the long gallery of European painting, we recognize that the majority of painters had occasion to paint recognizable likenesses, of the donors of altar-pieces, of monarchs, and of the anonymous people who served as models for the characters of history, mythology and religion, the subjects that primarily concerned painters before the seventeenth century. Few painters before Van Dyke would have thought themselves so specialized as to be described as portrait painters, although we might so regard them. At first portraiture appears the exclusive concern of courts, so that we habitually link the painters to their royal patrons: Philip IV and Velasquez; Holbein and Henry VIII; Elizabeth I and Hilliard; Charles I and Van Dyke; Charles II and Lely. There are others, but these names fit together like bread and cheese. They lived at court and worked for the household in much the same way as the stewards and cooks, the tailors and the cabinet-makers. Their rewards must have been more akin to a salary than a fee, and been awarded, no doubt belatedly, as honours, presents, privileges and pensions rather than as precise sums of money. The sense of rightness, of fitting together, so that the painter's qualities match the monarch's image to perfection, is characteristic of those I have paired, and presumably results from the artist-patron relationship of the time. We know that these painters were called on to design clothes, and entertainments, and, in the notable case of Rubens, to conduct diplomatic services, and it may well have been a happier and more rewarding way of life than most modern men imagine.

In France, and wherever there remained an active authoritarian monarchy, this relationship continued, but the social changes in England and Holland allowed the rise to power of more ordinary men, merchants and landowners, who were rarely in a position to dispense exclusive patronage. In the arts their needs were soon met and we recognize a new role – the professional portrait painter, independent of permanent patronage, accepting what trade comes his way, and charging what fee his market will bear. As ever, such freedom leads to greater insecurity, but it does allow more painters to compete, and who can say which pattern is the more admirable, or who, in the long view, will profit by such changes.

I think of Frans Hals and of Gainsborough, and suspect them both of painting, all too often, carelessly with the fee uppermost in their minds. Yet their pressing needs have left us with the more pictures. I think of Vermeer, who did not paint for a living, and note how few pictures of his there are to enjoy, in spite of the forger's determined efforts to fill the gap. I think of the young Rembrandt painting all those shiny burghers and splashing the money joyfully around, and then growing older and sadder and wiser and so fine and noble a painter that he outgrew his age not by a few decades, but by two centuries and more. I think of

one painter, Sir Joshua Reynolds, who met the demands of his time so well that later generations could barely tolerate so fortunate a combination of temperament, time and talent. Sir Joshua might serve as an ideal for the professional portrait painter, did not such efficiency border on the complacent. Unmarried, cultivated, of regular habit, urbane and conscious of the value and virtue of his aesthetic philosophy, all these solid Georgian qualities were anathema to the romantics of the last century, and they are certainly a barrier to our sympathy now. Yet such was his ability and integrity as a painter that almost any of his portraits will hang alongside the work of others and stand firm against criticism.

If you compare his work to that of his contemporaries and followers his stature will emerge, for the Romneys will be revealed as shallow and too fluent, vapid by comparison, whilst the Raeburns are all flashy histrionics, the chiaroscuro banal. The Ramsays are too timid, and even the Gainsboroughs are too often marred by careless clichés. The latter, and some others, may occasionally surpass Reynolds, but I know of no other British portrait painter responsible for so ably sustained a body of first-class work.

It would not appear irrational to suppose that those portrait painters to achieve very great, even excessive, material rewards are those with great talents, who share, quite genuinely, the values of the ruling caste of their day. This would apply as much to Van Dyke, El Greco and Velasquez as to Lawrence, Millais and Sargent. It is so often glibly assumed that flattery will assure success, and yet I doubt very much if any of these painters intended flattery. I suspect that they saw their models as they appear to us in the paintings, and painted what they saw to the best of their ability. They were, of course, fortunate in that their customers shared a similar vision. Did Henry VIII see his courtiers with the same precise clarity as Holbein, and did Goya's patrons recognize the unpalatable truth of his sardonic revelations? Perhaps they did, if not for themselves, then for everyone else.

When I consider the history of portrait painting, or when I am able to see a retrospective exhibition of a man's work, or when I recall my own experience, I am conscious of travelling a well-trod path that offers recurring pitfalls that I am powerless to avoid and recognize only in retrospect. Yet they must be obvious to the simplest intelligence. Perhaps the most insidious, and therefore most dangerous pitfall is that the painter accepts for his own the values and prejudices of the society he is paid to depict. It is very flattering to be suddenly associated on easy terms with the wealthy and the powerful, who prove, more often than not, to be more charming and friendly than one had previously supposed. From this one aspect of the portrait painter's situation may develop a desire to put the patron's wishes before your own better judgement, the assumption that you can and should enjoy the same way of living as he enjoys, and a ready acceptance of the high value that he seems to place on your work. Such an identification is likely to result in the repetition of conventional paintings by a pretentious sportsman committed to a standard of living above his means and misguidedly convinced that he enjoys an artistic status comparable to Raphael's.

In contrast to this enviable, rather than admirable, figure there exist, I believe, a number of potential portrait painters who reject the task because they are

prejudiced against any group of people that do not share their values or who are richer or more successful than themselves. Theirs is surely the graver error, for not only do they lose the opportunity of painting more people for more money, but posterity fails to secure good portraits of the men of the time. Posterity may be forgiven for regarding the first of these painters as a pleasant ass and the second as a sullen fool.

A not dissimilar dilemma concerns the painter's studio, for he can hardly expect to entice the self-indulgent to a cold and squalid workroom in the outer suburbs any more than he can afford, until he is so successful that it does not matter, to rent a handsome studio in a fashionable quarter. My own solution was to take myself and my paints to the patron's house, and I have become so accustomed to driving, and working in unfamiliar surroundings that I take such a course for granted. Nevertheless it presents difficulties for the painter who has no car, or who likes only to paint in his own studio. It is surely good sense to organize a realistic pattern of work that allows the most freedom to work for the painter and the least inconvenience for his sitter. If you cannot afford a studio in the centre of London or New York, and you cannot bear to travel and work in strange quarters, then it might be wise to have a cheaper but more commodious studio at some strategic point in the country; but if you do this, you must realize that you may be obliged to entertain and feed your sitters adequately. With this, as with some other problems, I can only suggest the nature of the dilemma and offer possible solutions. The choice depends on the painter's character and background as much as upon material considerations.

This condition applies particularly to the question that must inevitably arise when the sitter has his first rest. Should he see what you have done, should he be encouraged to comment, and should you take any notice of his remarks? There seem to be two schools of thought, related to the familiar opposites, introvert and extrovert. The first answers yes to all three questions and the second says no, and both are probably right for their peculiar needs. I belong to the yes faction and back up my intuitive decision with the rationalized arguments that it would be well nigh impossible to hide the work from a determined customer, rude to stifle his remarks, and unwise to disregard comments that might well prove embarrassingly apt. If you are committed to such an exposure, then you might as well exploit it and fix up a mirror behind you so that the model can watch the painting progress. In the majority of cases, such a revelation of another's problems should enlist his sympathy and understanding and allow him to accustom himself gradually to the shock of seeing himself through alien eyes. With a self-opinionated model such a course might well prove fatal, so it would be wise to reveal the mirror only when you have some notion of your sitter's character. As for the comments and criticism, these I have found useful only when I have remembered to discount their face value and seek their cause. The conventions of light and shade are unfamiliar to many children and a child will question the dark areas on his picture's face. Most people will describe the result, not the cause, naturally enough and complain that you have the nose too long when, in actual fact it is the chin or the forehead that is too short, or they will think the hair too dark because it is as

yet surrounded with a contrasting light ground. I have always feared that the alternative policy that reveals only the completed painting might prove too much of a shock for the sitter; for it is unlikely to conform to his imagined picture of either himself or the painting, and unless it surpasses both, it will inevitably disappoint.

There has for long existed a tradition of comparatively short sittings spread over a considerable period of time, such as two afternoons a week for several months. I assume that it derives from the convenience of a metropolitan studio and the ample leisure of the monied classes. I have always found so broken a pattern of work wasteful and frustrating and I believe that the once leisured classes now work for most of the week. I therefore prefer to pack the sittings into the closest practicable span of time. I try to arrange to paint someone all day, over two or three consecutive days, such as a weekend, or for two spells of a day and a half each, or paint a family during the holidays, all day and every day until their sittings are done. The majority seem to find this pattern acceptable, for it allows them to get done with what must appear in advance a rather daunting experience. Most adults can tolerate sittings that last from about ten until twelve-thirty in the morning and from two until four-thirty in the afternoon, although children and very old people might find three hours as long as they can manage on the one day.

The major advantage to myself is that such a compressed sequence of sittings allows me to give my undivided attention to one painting until I have completed all that part of it requiring the model's presence. It entails my starting more work than I can finish during the summer months, but it allows me to finish the clothes and backgrounds in a more leisurely fashion during the winter. For some reason – the weather or the economy – commissions in this country come with the spring and go with the fall. Ideally, I would prefer to complete each work in its entirety before beginning another, but I realize that painters of a different temperament may well develop a pattern that allows them to work on a variety of projects at once, attending to them as they feel inclined. Accepting commissions for portraits precludes either type of painter from achieving a pattern of work entirely to his liking. He will inevitably have to evolve arrangements that compromise with the realities of the current mode of life. The essential task is to distinguish between the purely administrative compromise and the aesthetic one, and it is more difficult to accomplish than to describe. Great fame, or self-esteem, may allow the painter to dictate what terms he chooses, but neither of these happy conditions are likely to be the lot of the painter with his living and his reputation still to make.

When I began to paint portraits, I did not realize that I was committing myself to a different mode of life than had hitherto been my experience, nor, I suspect, do many painters when they embark on a certain pattern of work. A majority of painters, designers and illustrators conduct their business through agents or galleries and have little contact with whoever finally buys their work. The portrait painter is involved with his customer from first to last and confronted with him whilst he executes the most important part of the work. If he is to enjoy this mode of life and work, then it must be supposed that he finds the company of others interesting and stimulating. Anything less would be hardly tolerable.

# Bibliography

*A Guide to the Salting Collection* and other illustrated catalogues
(Victoria and Albert Museum Publications, London)

*A Treatise Concerning the Arte of Limning* by Nicholas Hilliard
(1912 Vol. of Walpole Society)

*Conversation Pieces* by Sacheverell Sitwell (Batsford, London)

*Bridgeman's Guide to Life Drawing* by George Bridgeman (Sterling, New York)

*Drawing the Human Head* by Burne Hogarth (Watson-Guptill, New York)

*Drawing Portraits* by Henry Carr
(Studio Vista, London and Watson-Guptill, New York)

*Dynamic Anatomy* by Burne Hogarth (Watson-Guptill, New York)

*Enamelling on Metal* by Louis-Elie Millaret (Translated by H. de Koningh)

*Looking at Pictures* by Kenneth Clark (John Murray, London)

*Painting the Human Figure* by Moses Soyer
(Studio Vista, London and Watson-Guptill, New York)

*Portrait and Figure Painting* by Jerry Farnsworth (Watson-Guptill, New York)

*Portrait Painting* by Henry Carr
(Studio Vista, London and Watson-Guptill, New York)

*Nude Figure Painting* by Hans Schwarz
(Studio Vista, London and Watson-Guptill, New York)

*Sir Joshua Reynolds' Discourses* (Scott, 1884)

*Starting to Paint Portraits* by Bernard Dunstan
(Studio Vista, London and Watson-Guptill, New York)

*The Art of Colour* by Joannes Ihen (Reinhold, New York)

*The Artist's Handbook* by Ralph Mayer (Faber and Faber and Viking, New York)

*The Artist's Methods and Materials* by Mario Bozzi (John Murray, London)

*The Painter's Pocket Book* by Hilaire Hiler (Faber and Faber, London)

*The Materials of the Artist* by Max Doerner
    (Rupert Hart-Davis, London and Harcourt, Brace and World, New York)

*The Nude* by Kenneth Clark (John Murray, London)

*The Raphael Cartoons* (Victoria and Albert Museum Publications, London)

*The Technique of Portrait Painting* by Frederic Taubes
                                      (Watson-Guptill, New York)

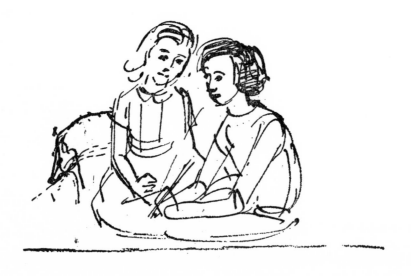

# Index

Agents 84, 85, 92
Amateur 8
Angelico, Fra 69
Art Exhibitions Bureau 83
Artificial lighting 66

Babies 58
Backgrounds 33, 40, 44, 45, 48, 57
Bloom 81
Botticelli 69
Book-keeping 85
Bone 63
Bourlet 83
Bristol board 62, 63
Brushes 36, 40, 64, 69

*Camera lucida* 15
*Camera obscura* 15
Canvas 36, 71, 72
Cardboard 63, 69
Cartoon 12, 46
Casein 69
Charcoal 14, 33, 67, 68
Children 39, 58–61, 66, 91
Chin 39
Clothes 42, 57, 60
Coloured chalk 45, 67, 68
Colours 34–40
Commissions 82–84, 92
Composition 11–12, 33, 47, 57
Conversation piece 7, 33, 46–57
Copying 11, 12
Cosway 64
Crayon 67, 68
Criticism 38, 90, 91

Dali, Salvador 62
David 42
Delacroix 12
Devis 46, 57
Drawing 8, 11, 12, 14, 15, 45, 46, 66–68
Dürer 15

Ear 15, 39
Easels 66
Egg tempera 69, 70, 71
Enlarging 14, 45, 48
Eye level 41, 44, 57, 66

Eyes 37, 63
Expenses 66, 84, 85, 89
Exhibitions 82, 83

Fees 46, 84–86
Feet 43
Fired enamel 65
Fixatives 68
Flattery 41, 90
Framing 83, 85, 87, 88
Francesco, Piero della 11

Galleries 82, 83, 92
Gainsborough 15, 42, 46, 89, 90
Gardner 69
Gesso 70, 72
Giotto 69
Glass on pictures 88
Gouache 64, 65, 69
Goya 7, 14, 42, 60, 90
Greco, El 90
Grounds 33, 63, 64, 70, 72

Hair 35, 40, 60
Hals, Frans 89
Hands 42
Hanging 87, 88
Hardboard 70, 72
Head 14, 15, 33–40
Hilliard 62, 63, 65, 89
Hogarth 46, 60
Holbein 15, 45, 62, 89

*Impasto* 70
*Imprimatura* 70
Ingres 66
Ivory 63

Jones, David 69

Kennington, Eric 68
Kokoschka 69

Latour 68
Lawrence 90
Lay figure 42
Lely 89
Lighting 41, 48, 58, 66, 88
Likeness 8, 12, 14–16, 47, 60

Limbs 42
Linseed oil 35, 81
Liotard 68
London Group 83

Manufacturers 35, 68, 69, 71, 72
Matisse 44, 69
Materials 34–45, 66–81
Mediums 34, 69, 71, 81
Metal 64, 65, 72
Millais 90
Miniatures 45, 62–65
Mirrors 16, 45, 91
Mixed techniques 71
Moores, John, Exhibition 83
Mouth 38

Neck 39
North light 66
Nose 15, 38

Oil colours 33–35, 64, 71–72, 81
One man shows 83
Overheads 85
Overpainting 33

Palettes 34, 35, 64, 71
Papers 63, 67, 68, 69
Parchment 63
Patrons 46, 82, 89–92
Pastel 68
Pencil 66
Pen and ink 45, 67
Perroneau 68
Perspective 57
Photography 45, 62, 86, 87
Picasso 88
Pointillist 65
Pose 11, 12, 41, 58
Posthumous portraits 87
Poussin 11
Preliminary drawings 11, 14, 46, 58
Priming 72
Private galleries 83
Professionalism 11, 82, 89, 90
Proportion 11, 12, 14, 41, 48, 60

Ramsay 90
Raeburn 90
Raphael 12

Rapidograph 67
Renoir 42
Rembrandt 7, 12, 15, 35, 67, 89
Rests 12, 41, 60
Reynolds 12, 15, 60, 90
Romney 90
Royal Academy 83
Royal Society of Portrait Painters 83
Royal Scottish Academy 83
Royal Society of British Arts 83
Rubens 11, 67, 89

Sanguine 67, 68
Sargent 90
Schools of art 8, 14, 65
Self-portraits 45
Seurat 11, 65
Sickert 14
Silver point 67
Sittings 7, 11, 33, 38, 41, 47, 58, 91
Sketch designs 46
Skin 36
Slate 63
Standing figures 43
Stretchers 72
Studio 66, 91
Sutherland 69

Taxation 66, 85, 86, 91
Teeth 38
Tempera 41, 69–71
Throne 66
Titian 11, 41, 60
Tracing 14, 45
Travelling 90

Ucello 57
Underpainting 15, 33, 35, 42, 71

Van Dongen 42
Van Dyke 7, 41, 42, 60, 90
Varnishing 71, 81
Velasquez 7, 15
Vellum 69
Vermeer 11, 89

Watercolour 12, 62, 67, 69
Watteau 45, 67
Wood 63, 69

Zoffany 46